CALEB NEELON'S
BOOK OF AWESOME

GINGKO PRESS / R77

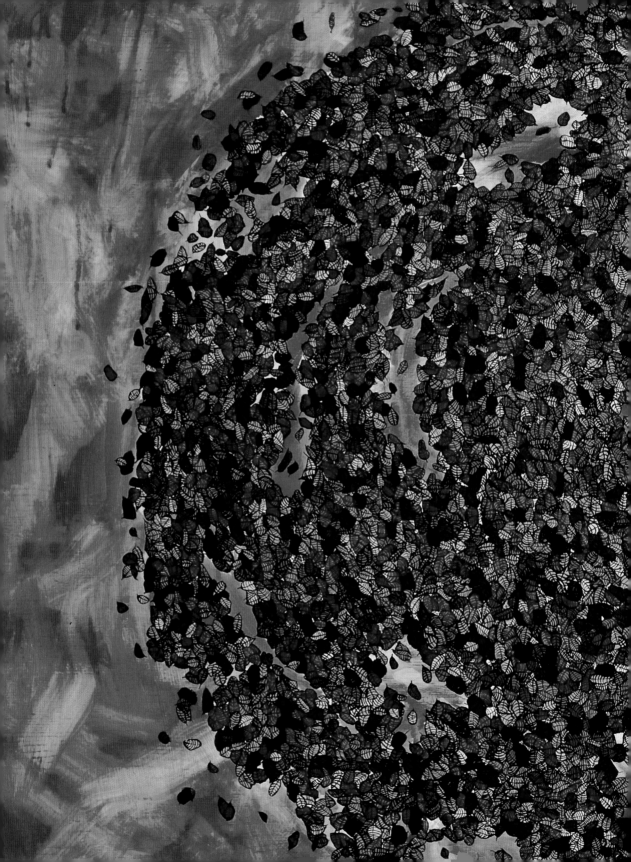

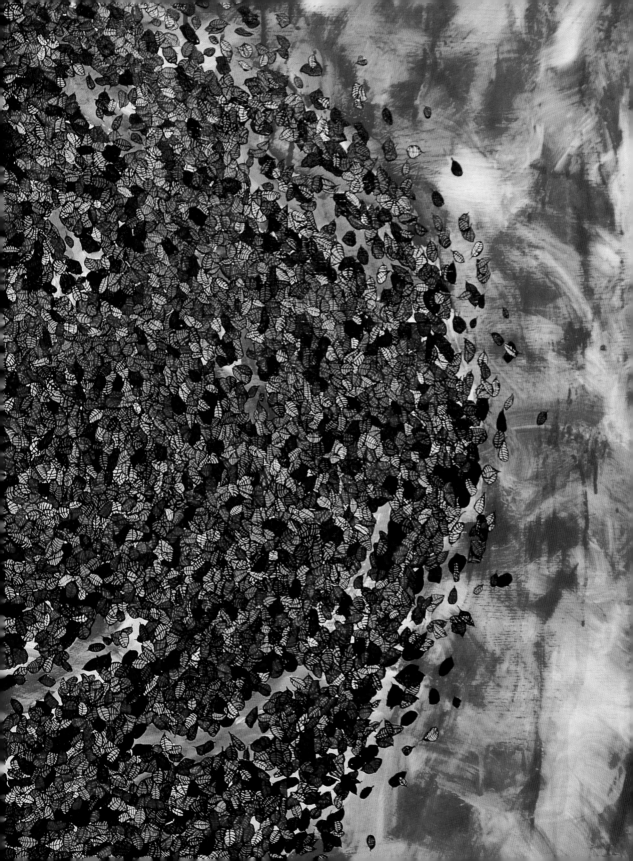

First Published in 2008 by Gingko Press
First Edition

Gingko Press, Inc.
5768 Paradise Drive, Suite J
Corte Madera, CA 94925
USA
Telephone: (415) 924-9615
Fax: (415) 924-9608
books@gingkopress.com
www.gingkopress.com

R77 Publishing
3111 Los Feliz Blvd. Suite 100
Los Angeles, CA 90039
USA
info@graffsupply.com

ISBN: 978-1-58423-306-0
Printed in China

Painted, Compiled, Written, and Edited by Caleb Neelon
Art Direction by Caleb Neelon and Justin Van Hoy
Layout and Endleaf pattern by Justin Van Hoy (www.thedutchpress.com)
Scanning and retouching by Ryan Shea-Paré and Leon Catfish
Foreword by Roger Gastman (www.rrockenterprises.com)
Interview by Alex Lukas (www.alexlukas.com)

Photography Credits:
Peter Tannenbaum did most of the photography of the art shows and all of the studio paintings
(www.petertannenbaum.com): Adam Wallacavage shot the Space 1026 show; Monk SCA took the photo
of the really old piece in Cambridge; Skeptik took the photo of Vitche and I painting in the Brazil section,
and a few other people have the odd photo in here, including Albano Mendes; Chris, Court, Alex & Mike;
several members of my family; and several people I happened to be painting with that day.
All the other photography is stuff I did.
-Caleb

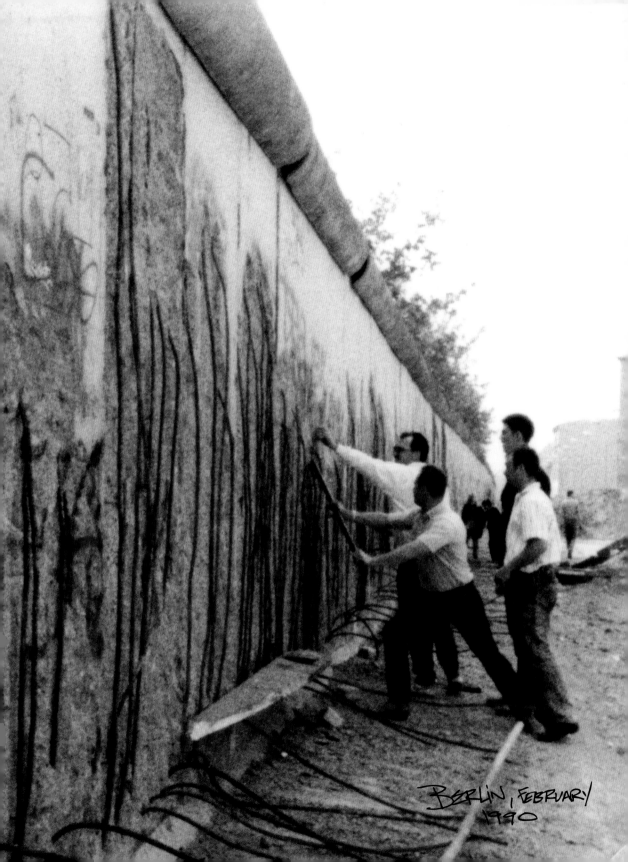

BERLIN, FEBRUARY
1990

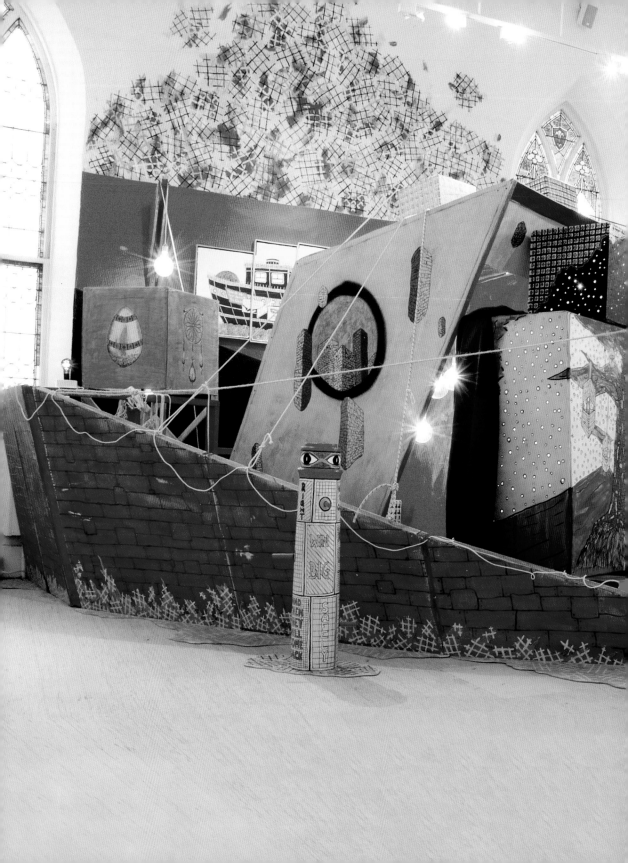

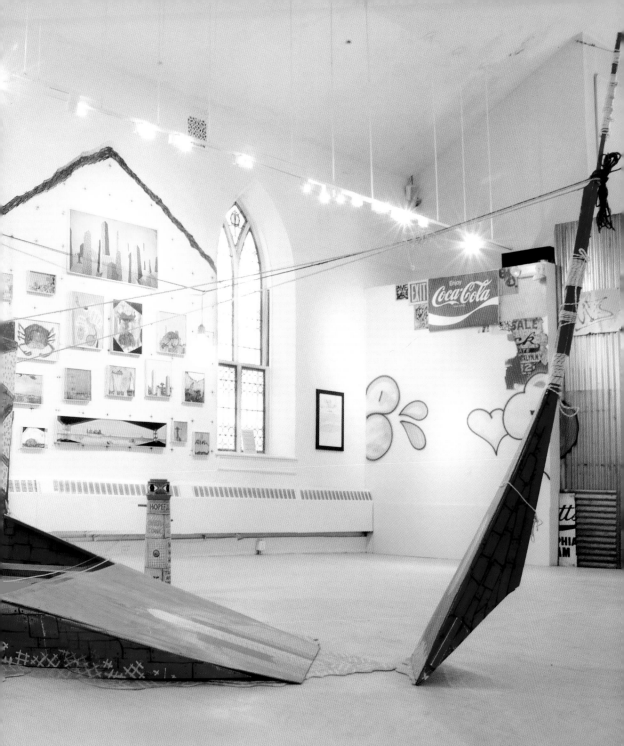

NEW ART CENTER
MASSACHUSETTS 2.006

I knew of Caleb Neelon well before I met him, and I think he would say the same about me. We're about the same age, and we both grew up on the East Coast surrounded by the fast, furious and (mostly) fun world of graffiti. We both had our hand in making late 1990s graffiti magazines that, for better or worse, helped define our current culture and first exposed countless artists who today are showing in fine art galleries all over the world. Before I'd ever met him, I knew the guy was part of my world. I just had no idea that he was part of so much more.

In many ways, Caleb was and still is much more worldly than me. He holds degrees from two fancy universities, but he'd probably tell you he has learned more in the time he has spent beyond their campuses. His travels, many of which are chronicled in this book, have often taken him to places that most of us can't even find on a map. He didn't go to these places with a tour group or on a vacation with friends; for the most part, he went by himself to explore and learn what these new places had to offer and let his mind soak up the culture and learn from it. I consider myself lucky just to be able to see Caleb's photos of his travels and hear him tell stories about them.

I'm constantly amazed by Caleb's skills as a traveler, how he always finds a way to fit in with the locals—culturally speaking, at least. And even when he's the only pale-skinned giant in sight, his artwork blends in perfectly through the universal language of color. His palette says joy, freedom, happiness and peace, and he gives those emotions as gifts to people through his art. No wonder he's so welcomed wherever he goes.

Similarly, Caleb's artwork has been well received by fine-art galleries spanning the globe. In the gallery setting, he infuses his installations with the energy and movement of his large-scale outdoor works, wowing critics and collectors. He has also received institutional grants and commissions that have helped fuel his creative process and output.

That's the thing about Caleb: he always seems to be giving – to communities, to families, to kids, to me. Every time I've gone to Caleb with a project, whether it's an art show or a magazine article, he has delivered with beautiful expression. He has written and illustrated a children's book; taught classes and created murals with kids; and written countless articles for international magazines, helping to push our subculture into the mainstream. It always comes from the heart, and you can tell because there are tiny pieces of Caleb everywhere in everything he creates, like he spilled his soul all over it. He never seems to run out, either. There's always plenty of Caleb to go around.

- **Roger Gastman**, Los Angeles, 2008

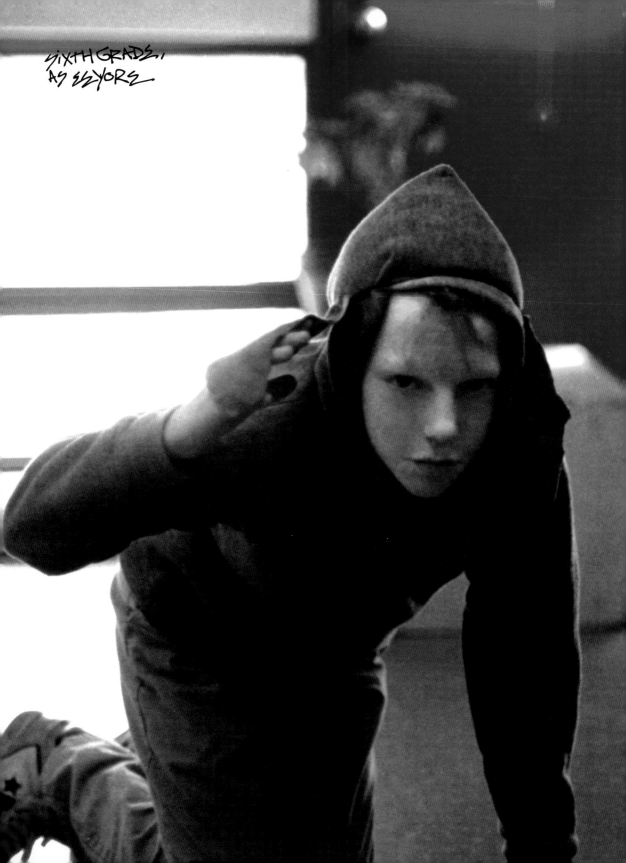

SIXTH GRADE,
AS EEYORE

The first time I heard from Caleb Neelon, it was a message on my parents' answering machine. "Hi, uh, this is Sonik, we haven't met, but give me a call." A mutual friend who was attending Caleb's high school alma mater at the time had been trying to put us in touch. Before everyone had e-mail, these messages of introduction could make for awkward situations, since in my house the answering machine was checked by the first person that got home. In this case, my parents heard it before I did. It was messages like the one from Caleb, a stranger with a pseudonym and vague intentions, which fueled my father's belief that I was selling weed. I wasn't.

Caleb—or Sonik, his graffiti name—was older than me and had a few more adventures under his belt, but we had common interests and background. He and I both grew up just outside of Boston with supportive parents who encouraged us to draw and paint and make a mess. Caleb had just finished college in Providence, I had just begun; Caleb painted graffiti, so did I; Caleb wrote for magazines, I was making Xeroxed zines at Kinkos; Caleb had been bitten by the travel bug, and I was just starting to feel that itch.

A few days and a few phone calls later, Caleb and I made plans to meet up at a barbeque restaurant one afternoon. He told me he would be the one wearing the "Brown Granddad" t-shirt, I told him I would be the one in the RISD cap. Embarrassing, I know.

We ended up getting along, and eight years later we're still talking.

- Alex Lukas

Tell me about the name Sonik.

It's a graffiti name that I chose as a teenager because I couldn't write Caleb Neelon on walls. Graffiti names are never as profound as you wish they were.

Were your parents involved in the arts?

My mother's family ran a frame and paint store when she was little, and she had artists in her family. She was a photographer, too. My father was also always very supportive. And both of them were and are writers as well. My mom did poetry and my dad did history and fiction.

So it was a creative family, a creative atmosphere then. **Was there ever an 'a-ha' moment of 'I'm going to be an artist,' or was it a natural 'this is just what I do' thing?**

It wasn't one moment. I think it was just having supplies lying around and the time and inclination to use them. Growing up, I had these great big sheets of what my mother called 'oak tag.' It's the kind of paper that manila file folders are made out of. She just kept it on steady supply, big sheets, like two feet by three feet, which when you're little is like the size of a carpet. Oak tag was pretty cheap, and since it's so smooth, it didn't dead my markers as fast as other paper would. I just had an endless supply of that oak tag, and I wasn't taught to think of it as valuable or special, just to use it. One cool thing about it, too, was that it had some heft to it; you could bend it and make it into 3D stuff. Dashboards, armor, stuff like that. And sometimes my folks would bring me a big cardboard box from an appliance or whatever and I'd make a spaceship or lair or something.

What do you think inspired your mother to get you that oak tag? Was it just an easy way to get you to be quiet that wasn't just sitting you in front of the TV?

I had to have something in my hands or I wouldn't sit still. That's still the case really. And I never showed any interest in video games whatsoever.

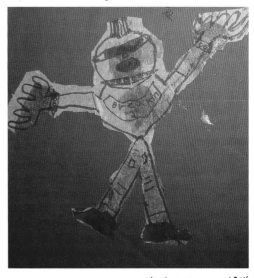

'BREAKIN' Z' CHARACTER 1984

That not sitting still thing is still with you, huh? I mean, you have traveled extensively, and beyond just your typical tourist destinations. Did you guys travel a lot as a family growing up? Is that how you got that bug?

My mother sometimes had these crazy ideas of where we should go. One trip, which was in the winter of 1986-1987, we went to what was then still very much the Soviet Union. We snuck onto an academic architecture tour or something else we had no business on, but this was in the time when you couldn't just up and go there. I was only 10 years old, but I definitely understood that just by being there we were doing something special. At that age I didn't understand diplomatic history or anything, but I could understand the concepts of Us vs. Them and the Good Guys vs. Bad Guys images that were in the news of the USA and the USSR. And of course in real life things were not so clear-cut.

And your first exposure to graffiti was at home, or on one of these family trips? I guess I should mention to those who don't know, you have written graffiti on five continents. So where did you first find it, or where did it find you?

Graffiti caught me a few times growing up. I remember the kids in the project behind my elementary school in Cambridge breakdancing on cardboard that they had markered up. This must have been 1982 or 1983. There was a graffiti piece on the back of my school around then, too – it said 'Kif,' but I have no idea who did it. And I remember seeing graffiti when we would go to New York for whatever reason.

But my real awakening to it all was in February of 1990. My mom took me to Berlin saying that something important was going on and that she wanted me to see it. That was the Berlin Wall having opened the previous November. The city was in a big state of flux, and I was a little 13-year-old bugging out on the graffiti on the Wall. Some of it was toilet humor and some of it was murals, but it was all free and the art had won: the Wall had come down. I ran around collecting pieces of the Wall that had graffiti on them. I took pictures of people tearing down the wall; kids picking at it with hammers. It was a very awe-inspiring sight. It took a year after that before someone explained

to me what a tag was, though. I was walking around with some kids back home and one pulled out a marker and did a tag. I asked; he explained.

And how long after that explanation did you do your first tag?

About 30 seconds.

What about graffiti stuck in your head so much that you wanted to keep at it?

Through high school, I never had any friends who did graffiti seriously, and I wasn't cool enough to find kids who were, so it kind of faded out for a bit. There was no Internet to answer my questions and only a few magazines, and those were hard to find. Before Providence, I went to college in New York for a year when I was 18, in 1994. I wasn't doing art of any kind at all, and that made me miserable.

OLD PIECE BY KIF, CAMBRIDGE

But in New York, Cost and Revs were at their peak then, and what they were doing was so innovative and so prolific – and really, much closer to the kind of work that I envisioned myself doing. So once I left New York and went back home, I started to try to figure out the way I was going to do what I wanted to do with it. That's when I started doing street signs, installing studio paintings, and doing things that were more mural than graffiti. And that process continued through while I was in college in Providence.

So what initially got you into graffiti was the traditional stuff, but that quickly changed.

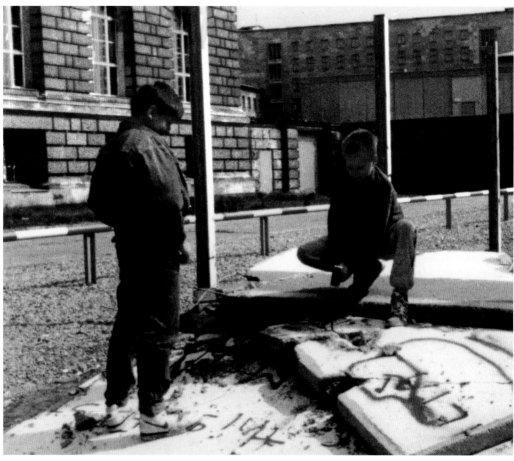

BERLIN KIDS, 1990

I was really having a lot of fun and painting what I wanted to see. One of the first things I got into was a weird way of doing outlines of my pieces. Outlines are the most carefully done part of a graffiti piece and everyone likes to make a big show of how perfect and clean their spray painted outlines are. So I used dripping black house paint with a disposable foam brush. It had this hovering look that I liked, and graffiti writers didn't know what to make of it, so I liked that, too. When I was really getting into this, I was in Australia on one of those cushy semester abroad things. I got to paint with Atome and many others who put up with the weird and frequently unsuccessful pieces I was doing. By then, I figured why not go as weird as I wanted.

Was that do-what-you-want attitude a direct extension of what you saw Cost and Revs doing in New York, both in the pieces you were doing at the time as well as the street signs and other less traditional methods you were using at the time? I think that is interesting, because where other kids go to New York and catch the traditional graffiti fill-in bug and come home and treat Boston like Brooklyn, you brought this alternative way of getting up away with you. What stuck with you about how Cost and Revs handled things? Have you seen anyone since then take the medium of graffiti in a direction that you have found as inspiring?

What I saw in Cost and Revs, as well as Twist, and then later Espo and Os Gemeos too, was a new way of working in the street that was very powerful because it was so personal and managed to be both irreverent and respectful of its

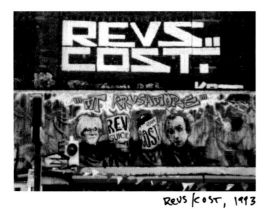

REVS/COST, 1993

predecessors. None of these guys were 'street artists' (and that term hadn't emerged yet anyway). they were just doing really powerful graffiti that pushed the medium forward. And perhaps most appealing to me was that it reached people other than graffiti writers, which is something I wanted to do too.

I think that is a really interesting goal, the idea of trying to reach other people, because to some degree graffiti on one hand is very public, but on the other, it is very much a closed-door culture, this 'if you can't read it, screw you' mentality. Beyond the visual idea of reaching out to new viewers, what was it that made you want to actually reach out into the community through doing murals with kids, teaching, writing and so on?

It just felt natural to me. I was a lot better at that than at sneaking around at night. And I like people.

So when did painting graffiti while traveling enter the picture? I have always been curious about people who paint and travel because on one hand it seems a perfectly obvious extension of traveling all over your city to paint, but on the other the idea of meeting up with other graffiti writers in a foreign country seems, if not unnerving, at least unreliable. How did this work before everyone had a laptop and checked their e-mail every five minutes? Would you just get off a plane with a phone number in your pocket? There seems to be a lot of trust there.

Yeah, once I figured out that I could paint everywhere I went, it was on. It never bothered me to travel alone, since that encouraged meeting more

people as I went. All you need is that first phone number. That's the beauty of it: go somewhere, meet a whole bunch of people, probably have a place to stay for free, and get a take on the place that you never would have otherwise. It made the process of traveling a social discovery one as well as a geographic one. It was a way of engaging with surroundings, and while it could be an egotistical way of looking at things, painting also turned travel into a giving process. That of course all depends on whether or not someone thinks of art in the street as giving or taking.

The other thing is that I don't pick travel destinations; they pick me somehow. Were it not for painting, I never would have headed to Brazil, Honduras, Bermuda, Iceland, Turkey, and so on. I'm always curious where the next place will be.

How do you handle work outside differently at home and abroad? I remember years ago you telling me a story about how some kid contacted you about painting in Kathmandu I think, asking for your blessing since you were the only foreigner to paint there at that point, and you replied with something like, 'Go for it, just don't roll up with a suitcase of fancy European spray paint. Use local materials.' Is that making-the-best-of-what-you-have mentality when traveling still important to you? Or was it a more basic fairness to the locals, like 'If I do this here, I want to do it so some other kid can come along and learn from it and not be stuck without materials?'

It's a fairness thing. Ideally, I'd love it if a neighborhood kid could see what I do and go give it a shot him or herself. So it has to be materials that are locally available, especially if we're talking about a less wealthy country, where using anything else is just really unfair. Besides, it's a cool way to push ahead a little: use new media, and also sharpen my eyes as to what the good materials are in a place just by walking around town and seeing what stays up.

And working at home, you have been super prolific with your own brand of street work. You did, what, over 500 hand-painted and installed street signs, among other stuff? But you always talked about feeling conflicted in working in your own city. Is that just being careful, or is it something about Boston and Cambridge?

Well, yeah, I do feel conflicted about Cambridge and Boston. An inspiring art scene, street or otherwise, is not why I love the city. I have to stay busy here, but I often feel like the best thing the city does is inspire me to spread my wings and do my thing elsewhere.

Why do you think that is? Because I agree totally, but even beyond Boston's rich graffiti history, it has such a long artistic tradition from Copley and Sargent all the way up to the 'happenings' in Harvard Square in the '60s and even further to the work going on at MIT's List Center today, for example. Yet somehow it isn't a city that does a great job supporting its own young artists.

Boston has a very well-deserved reputation for being behind the times, stodgy, and, worst of all, oblivious when it comes to art today. It's a very tough cycle for a city to break, because that drives out the kids who would fix the situation and keeps away the travelers. I'm going to hang around and fight, though. I don't think a person should have to move away from their loved ones just to make a living doing art. And if enough people stick around and find each other, it'll get better.

So how did you get started writing magazine articles? Initially, they were mostly for graffiti mags, right?

Both my parents were writers, so it was expected of me to at least be good at it. I did things like write for my high school magazine. I always liked graffiti magazines, too, and they were few–*IGT*, *Skills*, etc.–and special at the time, and without them I would have been held to a pretty limited radius of what I could see. Again, no Internet yet for anyone but some serious nerds. But when I was 19, I luckily met Allen Benedikt–Raven–who did *12ozProphet* as a RISD side thing. He was walking down the sidewalk and wearing a homemade 'Prophet' shirt. I stopped him and asked if it was a *12ozProphet* shirt, and he looked very surprised and said that he was the guy who made the magazine. Then he asked me to do an introduction for Twist, who was the cover of his next issue, and also a big hero to me and a zillion other people. Realizing that in graffiti there was a dearth of text available for people to read, people were hungry for it. And this was remarkable for me, being 19 and being put in a position where there was in any small way

an audience. And that led to writing for some other graffiti magazines, which led to writing for other kinds of magazines, books, etc.

Were some of the early magazine articles that you wrote, I'm thinking specifically about the Os Gemeos article for *12ozProphet*, the result of taking a trip to paint and coming away with a story, or was the goal of that trip to write that article?

I really wandered blindly into the Brazil story, that's for sure. I try with travel not to have the goal ever be to come away with a story, but sometimes one leads to the other. Getting some painting done could always be a good goal for a trip, though. Writing was a way to process what I was doing. It was a way to give some shine to people I really admire. And it was an excuse to go to places and meet people. And the feedback I got was positive enough.

SOME MAGAZINES

Have you ever found it challenging to kind of have your foot in a number of camps, being both practitioner and reporter, or reached a point when it becomes hard to write objectively about an experience or a person or, I guess, a whole art form because you are too close, too involved?

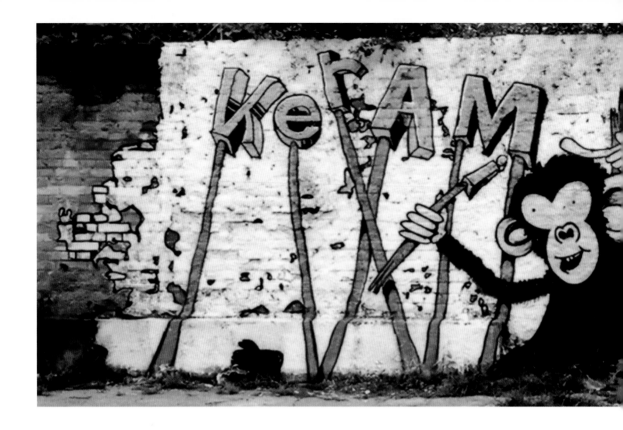

Not really. Objectivity is a tricky and problematic thing to chase, if that's your goal. Honesty is a lot easier and I've always tried for that, however corny that sounds.

Honesty, I guess, is something I think a lot about with graffiti writers today. I think we can all acknowledge that graffiti today is not just an art done by underprivileged urban youth without art programs or whatever, it is no longer the voice of the ghetto. So many graffiti writers we know came from supportive artistic households, were attracted to graffiti because they were interested in art already as opposed to being into hip-hop, then graffiti, then art. It is almost like now you make art first, then write graffiti and then transition back into art, but art that is informed by the act of painting quickly and illegally outdoors. How did this transition go for you?

Sort of like that. There is absolutely no feeling on earth like finishing something cool in the street, because what you've just done is alive and breathing and a part of people's lives because it came to them,

not the other way around. Walking away from a big spot you've just done is just the best feeling in the world. That satisfaction is always harder when the art making process begins with phone calls, emails, proposals, and meetings. And suddenly, money rears its head. What's challenging is trying to find a way to make the indoor-art-making satisfying: you need to play the artist game of finding the right venues and support systems to do bigger and more daring things. That part sucks, but when the opportunities do arise, it can be really great.

But you have had some success doing larger scale installations, between the show with Andrew Schoultz at the Mills Gallery at the Boston Center for the Arts, the show at Space 1026 in Philadelphia and the Spothunters exhibition at the New Art Center. How do you begin to approach those opportunities?

I'm attracted to indoor spaces in the same way that I'm attracted to outdoor ones. Installations make it possible to really wrap a viewer up and let them settle into a space in a way that people can't

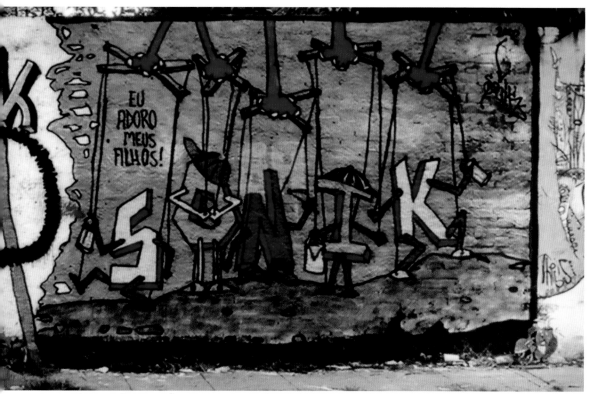

KERAMIK, SONIK, THESIS SÃO PAULO. 2002 MINE SAYS 'I LOVE MY KIDS!'.

outdoors. When I walk into a space and I see every surface and space has been done up, it feels good. So I try to keep the installations I do a real walk-in experience. And these shows give me a chance to build big boats and have a place to put them for a while. But these things all do start with phone calls, emails, proposals, and meetings.

Is there a similar mentality (with the installations indoors) to some of your mural work in terms of planning and vision, or is it a totally different ballgame? And beyond that, how do you relate the outdoor work to what you do inside?

I've always wanted to do both and in some ways each functions as a lab for the other. Street stuff is quicker, and if I make some throwaway work then who really cares, it's just a flick I won't show people. Indoors, since the opportunities are more precious, there isn't that same experimentation, but the upshot is that it offers an opportunity to sit and sit and sit and patiently refine ideas in ways I couldn't do outside. I can see myself swinging back and forth between these two for the rest of my life.

Is the spontaneity of work outside something you miss when in the studio? The fact that you just have to get it done and get out was something that I always found appealing about working outdoors.

Absolutely. But the funny flip side of it is that working outdoors also encourages repetition. You do the same thing 500 times in the street, you're up. You do the same thing 500 times in the studio, you're boring.

One of your indoor projects that I was always interested in hearing more about involved paintings you did in a hospital. Can you talk a little about that project and how you approached it? It wasn't your traditional hospital art project...

I did a project at Mass General Hospital painting the 2-foot-square ceiling tiles directly above patient beds in the Medical ICU. This was a unit where most of the patients are older and at a stage where they are hooked up to a lot of apparatus. Somewhere around a quarter of the people who go in do not go out. Because the painted tiles were directly above

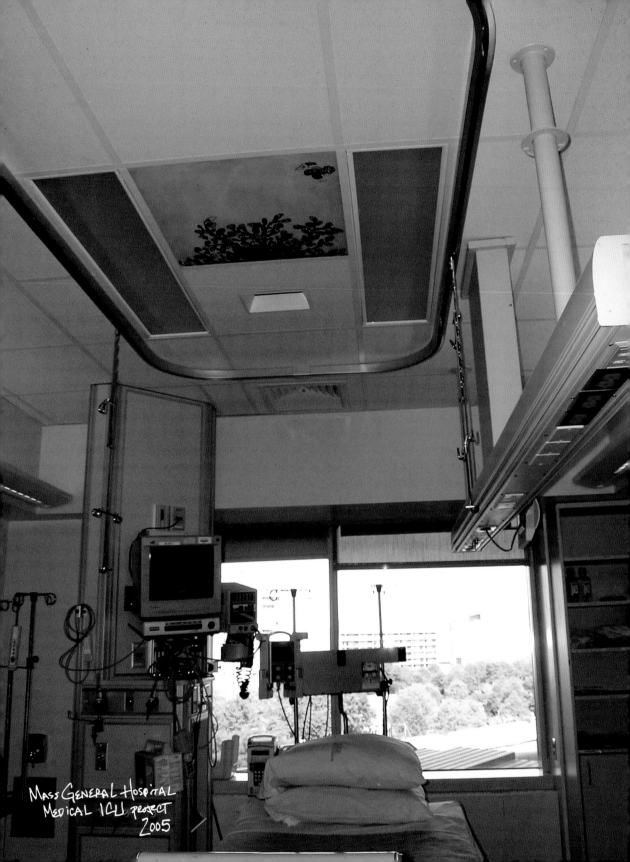

MASS GENERAL HOSPITAL
MEDICAL ICU PROJECT
2005

the bed, this meant that these paintings would be quite literally the last thing that many people see.

Projects like this have to originate within the hospitals, of course – I can't go in and pitch something like this. But I would gladly do this again and again in other hospitals if asked. What made this different from a lot of art projects in hospitals was that it wasn't in public areas, like a waiting room or lobby. In fact, it's even kind of hard to see the tiles as a visitor in the patient room unless you are looking up at them from the patient bed. But of course, that's where the greatest need for that art lies.

Painting these tiles was the most humbling art-making experience I've ever had. My hands would shake and I would wrack my brain thinking of subject matter appropriate to the situation. And again and again I would return to the imagery that summoned, at least to me, the magic wonder of childhood when the days last forever and couldn't be more beautiful for it.

I also had the honor of putting a few other artist friends in on this project to do the same thing. They all did beautiful work and I'm very grateful that they took on this challenge as well.

You mentioned your childhood again. There is a popular phenomenon in a lot of contemporary art made by 20- and 30-somethings today, where artists reference growing up through either faux-naive imagery, tongue-in-cheek references to '80s pop culture, or this idea of creating some D&D-inspired world of make-believe for their art to exist in. Maybe it is some sort of generational nostalgia for our childhood or a reluctance to admit we are all getting old. Your work is constantly referencing your childhood, but you have done this in a different way. Your approach seems to be very honest and un-self-conscious. A lot of your imagery, be it boats or your little blue men, are icons you have been using since you were like five years old, no? What is it about your childhood that continues to inspire you?

There's a reason they call them 'magic' markers, you know? I don't feel a lot of nostalgia for my childhood so much as I've never left that magical period, art-wise, in some respects. What happens is that I'll go

look through my old drawings from when I was little: I'll find a drawing from 25 years ago that is the same image I painted six months ago – a long, long cargo boat or something. But when I look back on my old drawings, I'm not looking to deliberately revisit old themes or do updated versions of them – I've tried that a few times and it doesn't work very well for me. What happens is that every time I make a painting, I look back and find I had done the same thing long ago.

JOURNAL THING, AGE 6 OR 7

So it isn't necessarily referencing a specific thing you made when you were young, but you find that the same images, or imagery, still resonate? Is it all subconscious? When you incorporate a new set of imagery, what do you use for inspiration?

Any new images I do tend to arrive without a whole lot of forethought. They simply present themselves somehow based on whatever I'm looking at, reading, doodling, or joking about with friends, and as I hold onto them and turn them over in my mind, some of them make sense and need to be painted, and some don't. Some imagery, for instance boats on jack-stands up on dry land, just never leaves me alone.

How do these turn into the almost mini-essays you write in some of your paintings? They are really filled with self-doubt and insecurity sometimes. You titled one especially ambitious installation 'Caleb Neelon's Unrealistic Expectations.' I'm curious about the convergence of these kind of dark feelings, feelings of insecurity and anxiety, contrasted with the bright colors and animal imagery that makes your work very inviting at

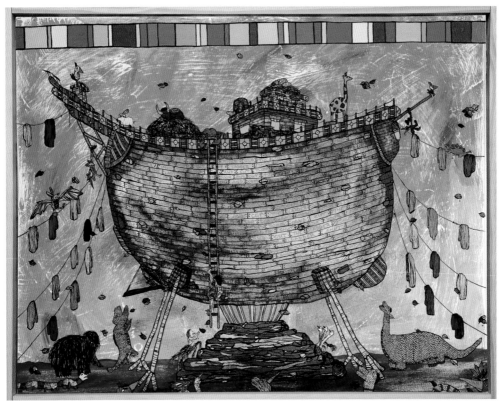

DEPORTATION PROCEEDINGS

first glance; the paintings are almost deceivingly carefree. How do you deal with that duality?

Well, in a very broad sense, a lot of the artwork I've done deals with encountering a situation immediately appealing and full of promise, looking more closely and realizing its drawbacks, and being at the point of decision as to whether or not to abandon it or not. To use a crass analogy from the stock market, it's the point of knowing that you've picked and invested in a loser. Do you dump it and take your loss, or do you emotionally trust in your choice that it–and your situation–will turn around? Now, that's a very banal example that only has to do with money – things get more complicated and charged when you are at that same point with relationships, aspirations, and so on. But nobody gets to that point without an inviting and carefree first impression.

The text pieces are a way to get past that carefree first impression – I paint those words small, much of the time, so on first glance they just read as 'text.' You need to get a little closer to read them. Many of the text pieces are imaginings of the internal monologues of someone in a particular situation – leaving home, facing a conflict of faith, an end of a relationship, or just stuck on one phrase that they can't help but repeat over and over again.

And you've said to me that one of the reasons you did graffiti in a less than traditional manner was that you never trusted your abilities in art. Do you trust your abilities now, or do you still have your insecurities?

No, I still don't trust my abilities. Never have. That's why I went to school to study literature, and later developmental psychology, as opposed to art, really. I've always been terrified that one day I will be forced to enter another line of work and have educated myself so that I'll have options for when that day I fear arrives. But by now, I'm an adult and doing my thing, and not trusting my abilities is just part of my method, I guess. I never will, fully.

Did you think you wanted to be an artist when you were thinking about college? Was choosing to pursue writing as a college career path a 'this is

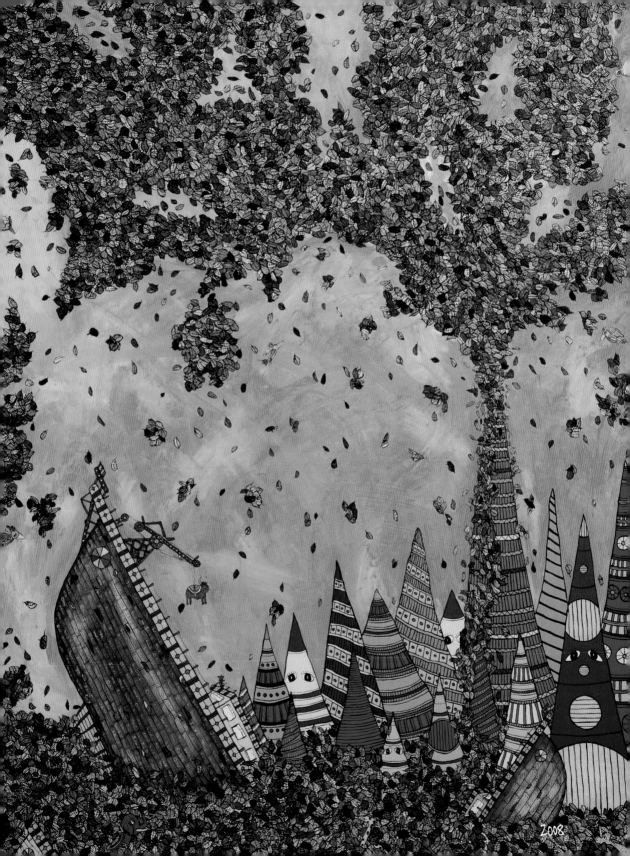

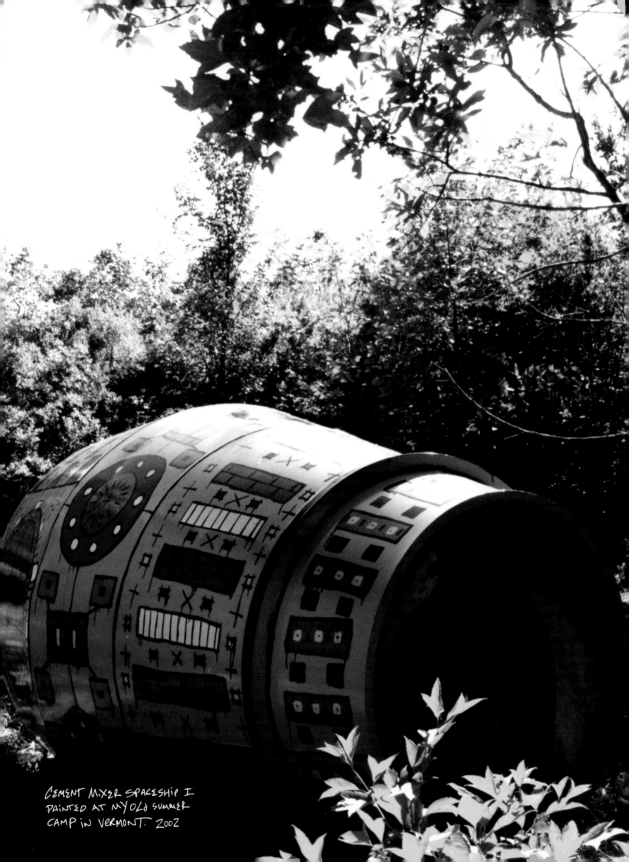

CEMENT MIXER SPACESHIP I
PAINTED AT MY OLD SUMMER
CAMP IN VERMONT. 2002

more realistic' decision or a 'I have to choose one, art or writing, I guess it'll be writing' decision?

It was definitely a 'this is more realistic' decision. More like a 'both are very unrealistic and represent a dream, but writing offers a somewhat better safety net' decision. It's the not trusting my abilities thing again. The funny thing as I've gone along is that periodically, a gallery person will tell me that I need to focus or whatever; that I need to drop the writing. Yet no editor or publishing gatekeeper has ever said that I should drop art; in fact they couldn't be more supportive. There's a value added in pushing art and writing that, in an oddly large number of cases, the writing people see and the art people miss. And that's always struck me as strange and I have no answer to it.

I like that you continue to do both. I think that's really important, to not only be able to talk about what you do, but to be able to report on what your peers are doing. I like the idea that instead of having an outsider say, 'Look what these kids are doing,' we can have an insider stand up and say, in an intelligent manner, 'Hey, check us out.' Do you hope to encourage other people to try to bridge both the doing and the talking about doing?

Sure. I'm happy that there are art people that completely get where I'm going and are quite supportive. And honestly–to any artists who might want to write articles for publication–90 percent of getting an article or whatever published is having an interesting subject and actually being willing to sit there and type it out and hand it in close to on time.

And you plan to continue to work with children? We touched on this briefly before, but in addition to painting and writing, you teach classes and do a lot of murals with kids. You got a Masters in Education from Harvard, no? There are a lot of people who are good at things and never try to teach anybody else. What's your motivation for working with kids? Did you see a void in how we educate our children and decided to fill it?

Nah, I just like kids. It's gotta come from that. I could spout off all this education theory and developmental psych stuff, but good teachers all like kids. Given the poor status of art education in most schools, I think one of the best things that can

1985

be done under the circumstances is to have artists visit classes and talk about how they've made a life doing what they do, and do whatever project fits the budget, small or large. I hope kids respond well to my stuff, because I certainly take their opinions to heart. And since kids pretty much universally think graffiti is just the awesomest thing ever, that helps. The day that kids stop thinking that, I'm through.

What are your plans for the future?

I have a wish list of things I'd love to do, but I keep a really open mind and people have done a pretty good job of keeping me busy by getting in touch with me for this or that project, whether it's through a mutual friend or a complete cold call. I'd love to do more artwork in hospitals and in new places around the world. I'm working on some history books and documentary films. And I'll keep making art.

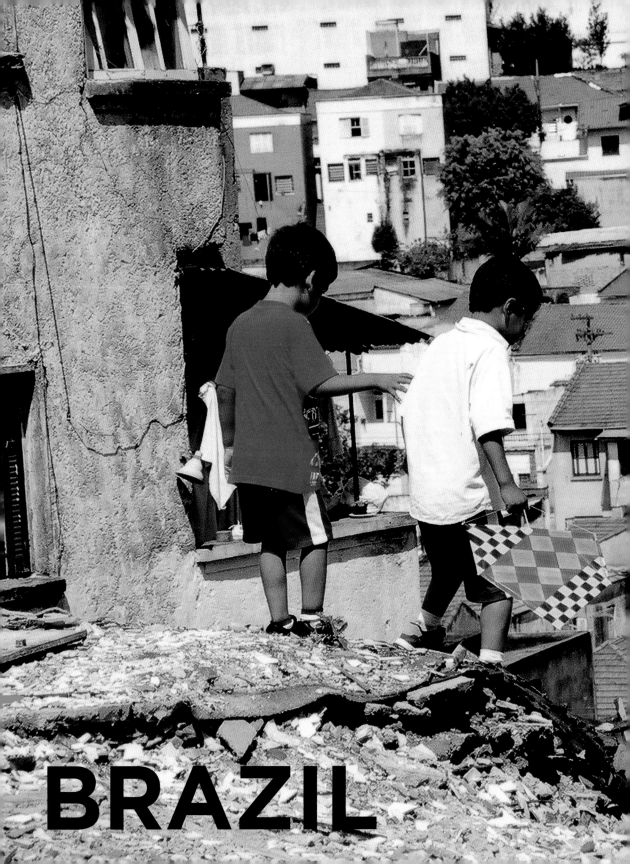

BRAZIL

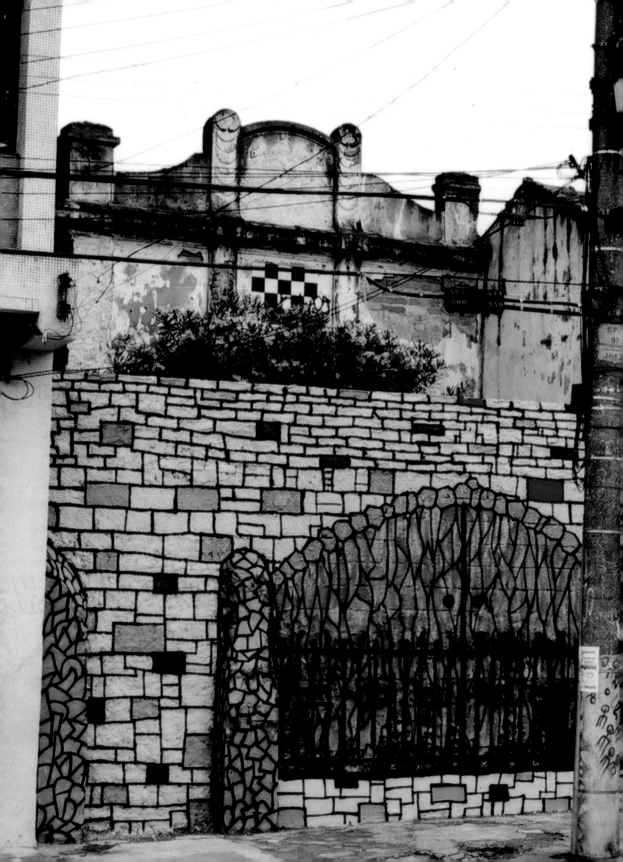

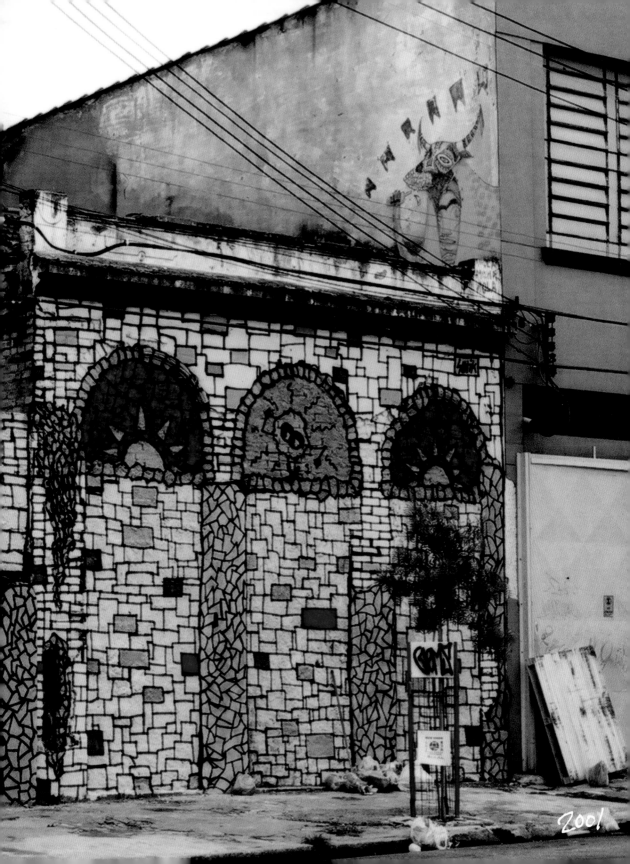

2001

As soon as I arrived in Brazil in 2001 I knew that I'd never regret having sold that car. The money I raised would just about cover four months of being a complete graffiti bum in Sao Paulo.

Back in 1997, my first trip to Sao Paulo scared the tar out of me and knocked my world silly. I spoke no Portuguese and knew nothing of what I was getting myself into. I was there to write an article about Brazil's graffiti scene for *12oz-Prophet* magazine and introduce it to the world as best I could via our hosts, twin brother graffiti writers Os Gemeos – "the twins" in Portuguese. And I pretty much fell in love. People tend to fall harder for Brazil than for other countries, and I was no exception.

Not far from my new house some years later was a big vacant lot with an old, pockmarked wall around it. I decided that it would make a good project. I had heard that a big beverage company owned the wall and the vacant lot, but they obviously weren't paying it any mind. And a lot of people had to see the wall out of their front windows.

The wall was facing a neat row of well-tended, colorful houses. The small, struggling trees planted along the sidewalk had been decorated all over with hundreds of bright pink plastic flowers. Normally, you'd think plastic flowers pinned on a tree would look tacky. Here, it looked great. Word was out quickly among the women of the neighborhood that I was some gringo who had sold his car to come to Brazil and paint murals for free. Now they were showering me with snacks and glasses of fresh juice; a few even gave me some money. I was introduced to some daughters. A glowing lady firefighter invited me to drop by for lunch at the nearby station.

Some weeks later after a Sunday of painting with a large group, we stopped at a wall at the beginning of a narrow cobbled dead-end street, full of well-tended houses with little manicured front lawns. We painted away, and as we each wrapped up, we sat around and goofed off. We were all filthy as you only get after eight hours of street bombing. Everybody was in a great mood.

A birthday party in the house next door began spilling lovely 10-year-old girls into the tiny street among us, giggling in pink, purple and yellow floral-patterned party dresses and matching ribbons in their hair. Three of the little girls walked, beaming, ferrying silver platters through the crowd, handing us slices of frosted lemon cake and cups of soda as we all painted up and down their street. It was pretty hard to keep from laughing.

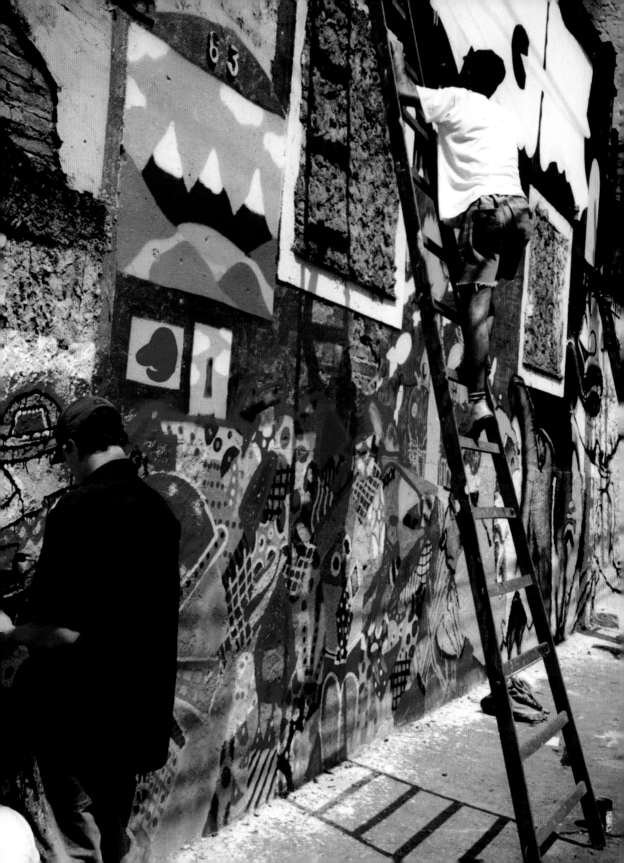

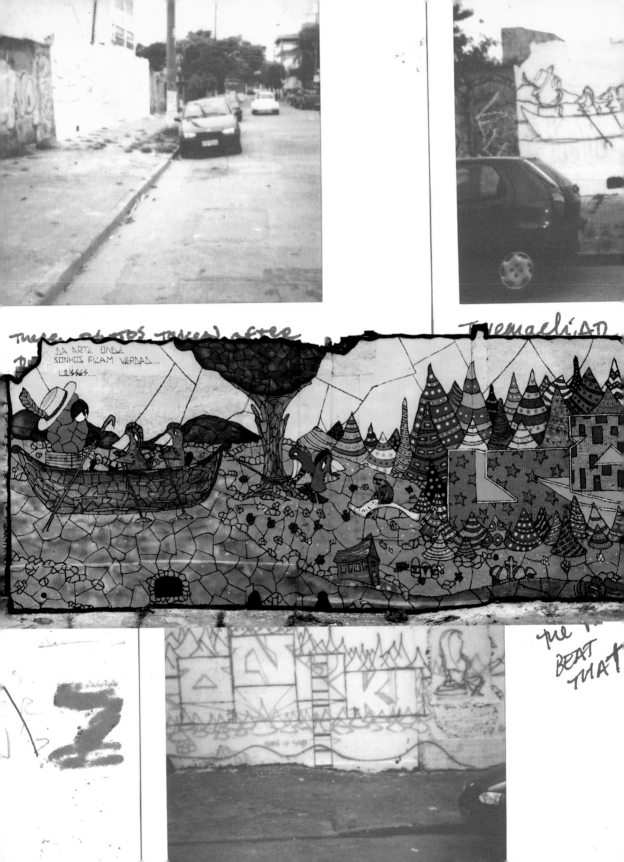

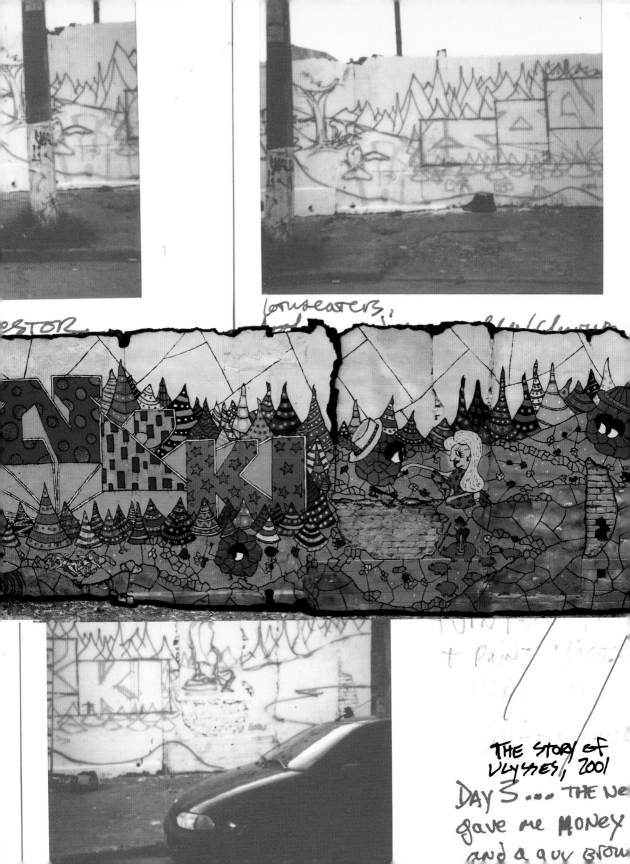

ESTOR

lotuseaters,

THE STORY OF
ULYSSES, 2001
DAY 5 ... THE N
gave me MONEY
and a guy Brow

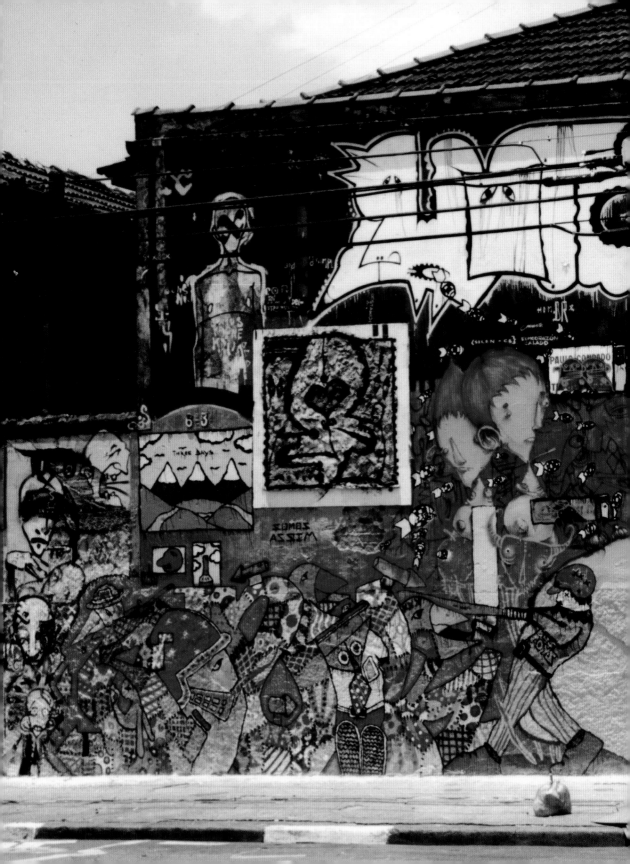

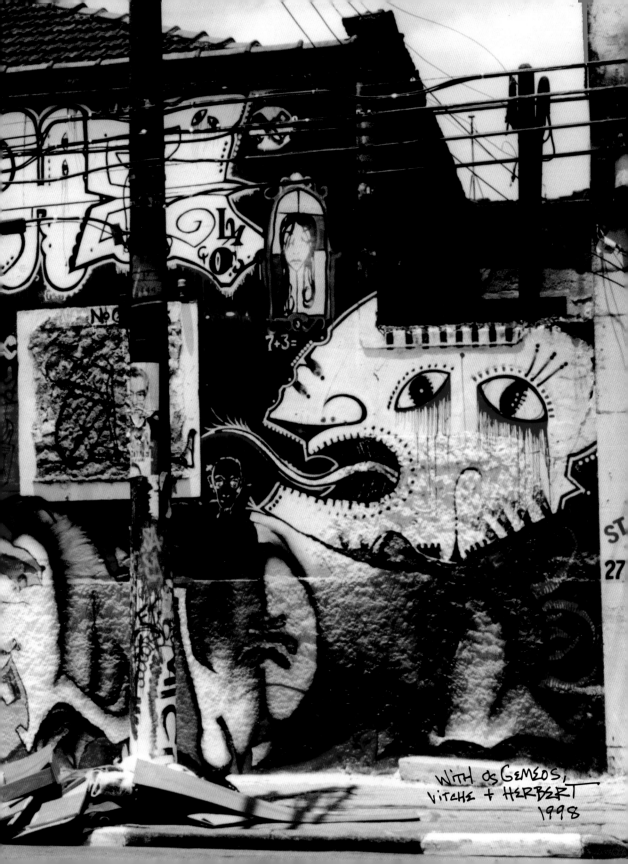

WITH OS GEMEOS,
VITCHE + HERBERT
1998

A gigantic apartment building stuck out as one of the strongest images from my trip in 1997. I craned my neck as we drove by as if it were some gory car wreck. It's 40 stories tall and nearly as wide, located near the center of the city in a bad neighborhood. It dominates its otherwise low-flung surroundings. The locals call it "Treme-Treme," or "Tremble-Tremble" – what it does whenever a truck rolls by. A third of its windows are broken, and another third have no glass. Who knows about plumbing and electricity. It's the smallest step up from being a squat. I shuddered to think of the conditions in which its thousands of residents lived.

I was trembling worse than the building when we pulled the car into a broad gravel parking lot next to Treme-Treme four years later. It looked the same, just another four years of weather and wear. My friends pointed to the wide concrete expanse of a wall in its shadow. This wall was inside a fenced-in and guarded car park. After finessing our way past the guard, we took turns painting high up on ladders, which meant one hour of painting and four hours of sitting around and fiddling with bits of gravel. I stared up at the decaying multicolored expanse of windows forming Treme-Treme's massive façade. I still couldn't fathom what it was like in there.

It had been quiet, but then the parking lot guard took a bathroom break, leaving the gate open. Two dozen little kids suddenly poured towards us out of Treme-Treme, yelling and playing. As soon as they heard my foreign accent they asked me a million questions all at once. I asked them what floors of Treme-Treme they lived on and they answered, breaking out into fights. Apparently there were some rivalries between floors. A charmingly rugged little girl told me, in between punches she was busy throwing at a smaller boy, that my painting of mountains floating on a cloud was her favorite of the bunch; that was nice to hear. When it was time to leave, the kids pelted our car with gravel.

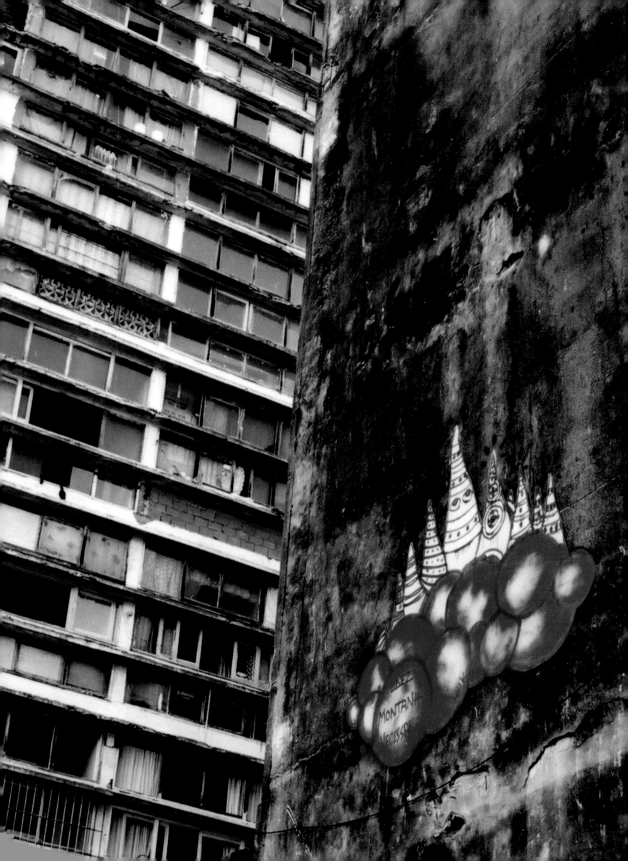

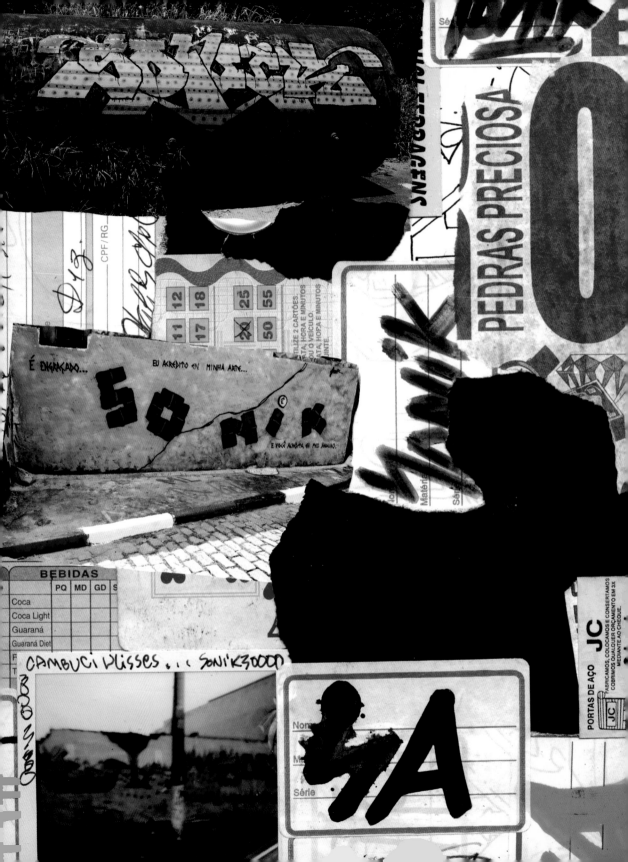

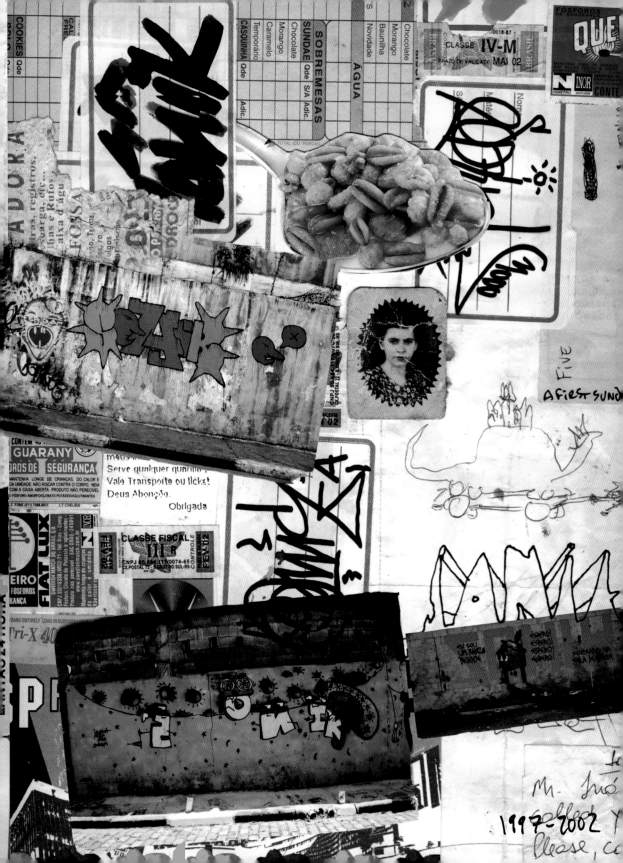

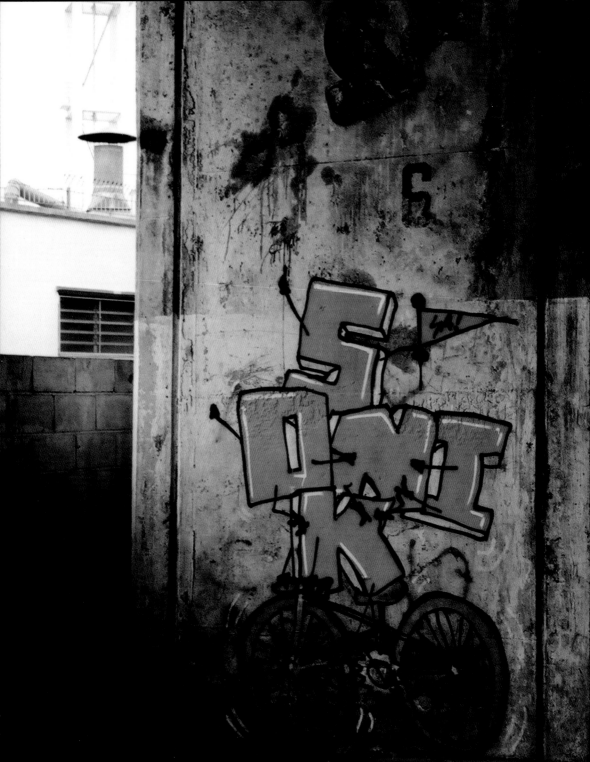

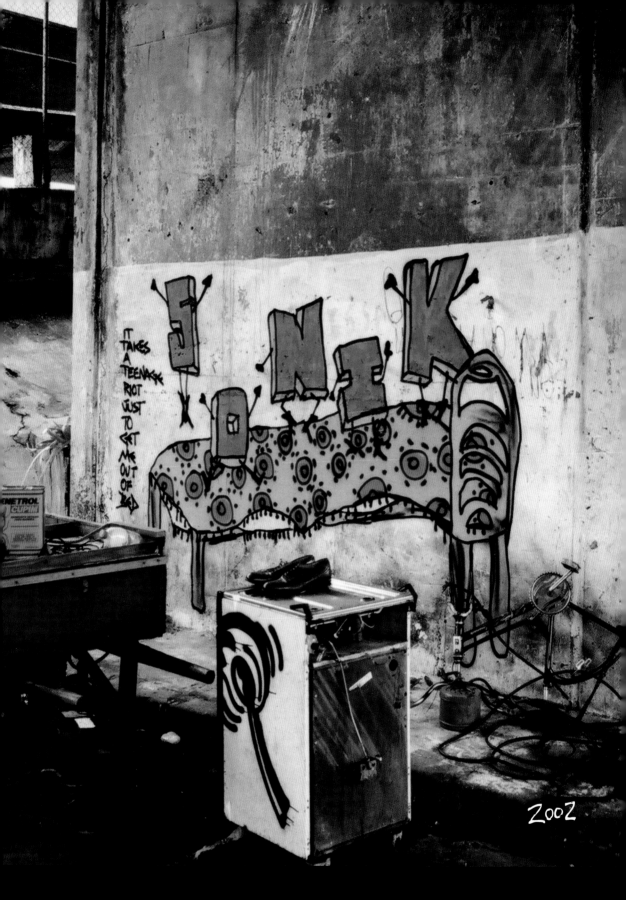

IT TAKES
A
TEENAGE
RIOT
JUST
TO
GET
ME
OUT
OF
BED

2002

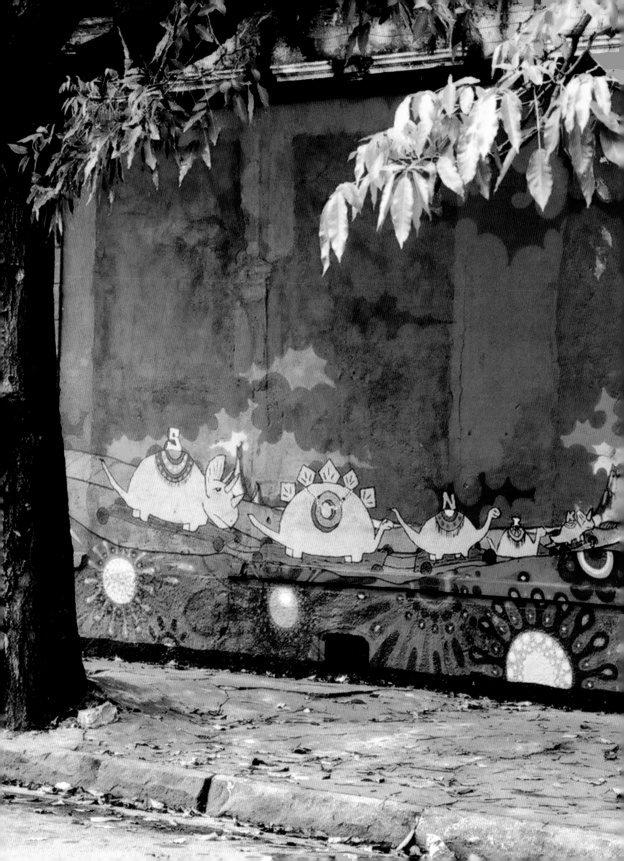

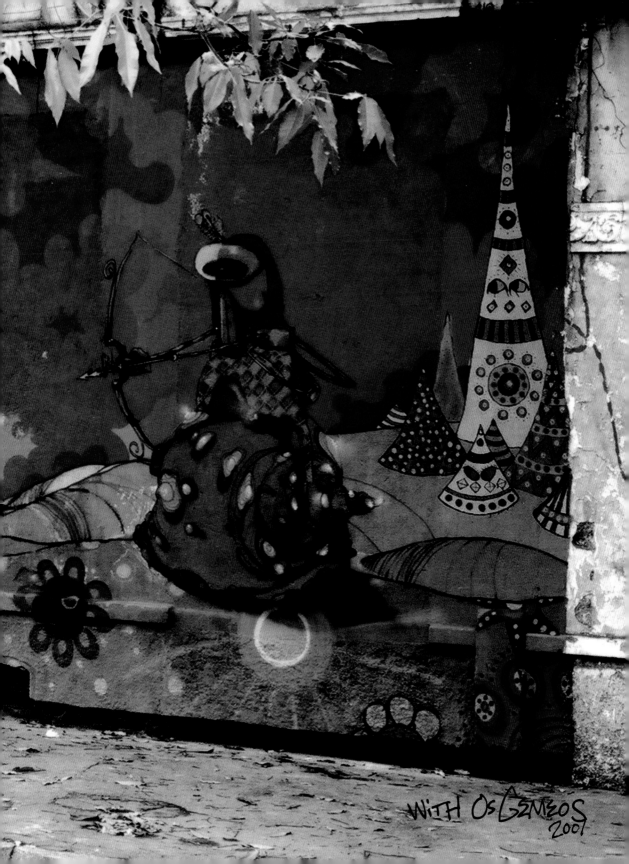

WiTH OsGeMeoS
2001

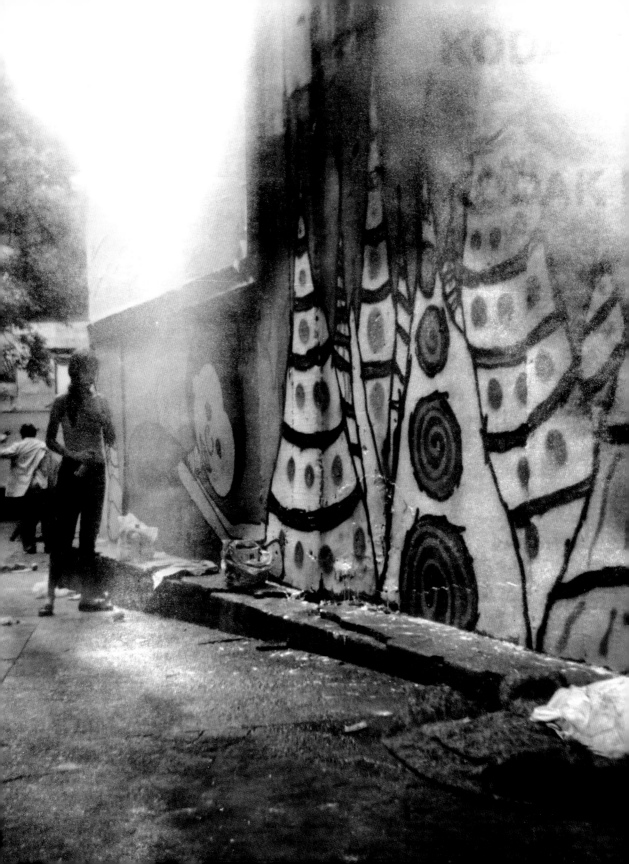

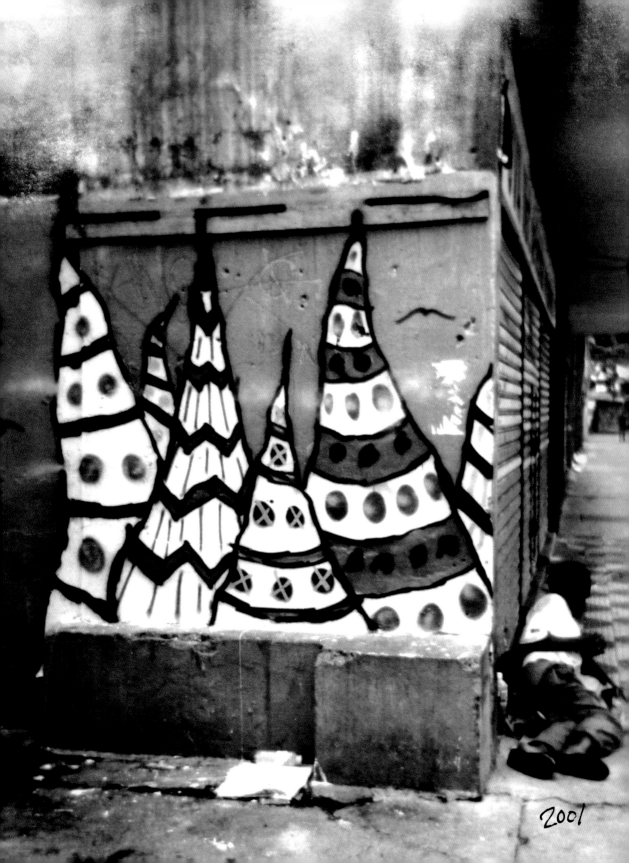

2001

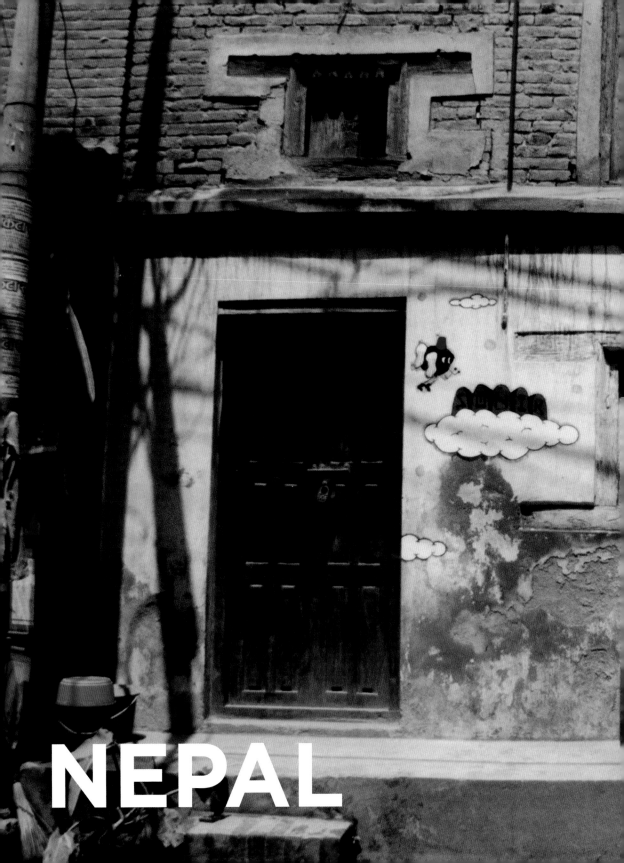

NEPAL

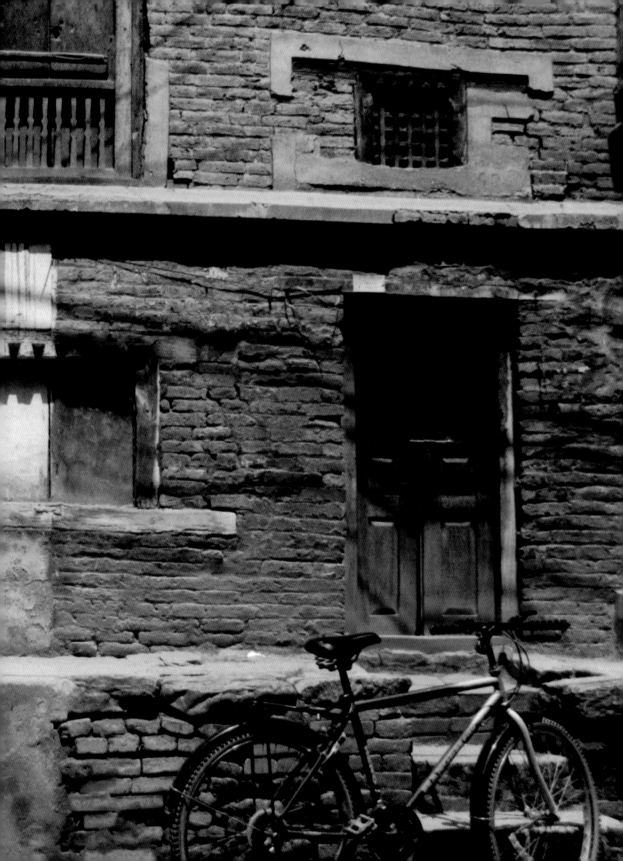

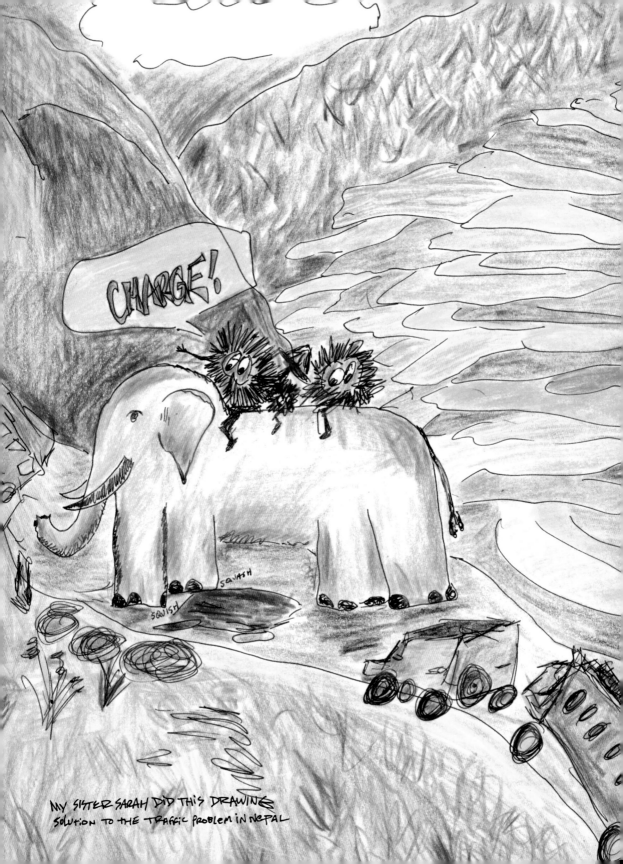

After breakfast of eggs and tea one morning, I go out to line up some more spots to paint. I leave my family's house, walk up to the main road, walk along the main road for a while, and head down a side street I hadn't explored before. Kathmandu is a maze of little narrow streets. And every few blocks, there's an attractive spot. In this case, it was the side of a little corner store. A bodega, you could call it. I duck my head down under the low doorframe and walk in. The owner is behind the counter and chatting with a guy who's there to buy a thing or two.

I don't speak Nepali, and the bodega owner doesn't speak English, so I pull out a little album of my stuff. I hand the album to the owner, point at the wall I want to paint, and make painting pantomime motions with a big smile. The owner is curious, seems to like my stuff, but politely declines. But then the other guy in the store looks like a light just went off in his head. He gets really interested in my album, then hands it back to me. He points at his chest, then spreads his hands as far apart as he can, with wide eyes. He's got a big wall in mind, this much is clear. He beckons for me to follow.

For well over an hour's walk, he leads me through the maze of streets, every so often beckoning again as if to say, "Just a little farther." I am so lost. There's not a word of language in common between us. I'm totally in his hands and have no idea where I'm walking. I love it.

We finally pop out onto a broader dirt road. Up ahead is what looks like a park with a swing set and some other kid stuff. This is unusual – Nepal doesn't have much in the way of those kinds of parks. And there is a nice-looking wall facing it all. I hope it's the one. Then my guy points right at it. Now I'm excited.

He takes me over to a house that faces the wall, and rings the bell. A man appears. They speak for a while, then the man turns to me and introduces himself, in English. He is on the park's committee, he says, and they want to do a mural. He hopes I can bring a sketch to their meeting the next day. I oblige with a sketch full of turtles and hippos and pigs and elephants and giraffes and ducks and a dinosaur and other kid stuff that is beyond reproach. I get the green light.

Nepal at the time was in the midst of a kind of civil war. Using violence, the extreme right-wing monarchy and the extreme left-wing Maoists had effectively excluded any moderate parties from the discussion of the nation's future. It was a bad scene, and people were scared and not especially hopeful.

Fortunately in a country with thousands of years of history, people take a long view. But it still felt like a scene out of Animal Farm, which by that time in most of the world was an outdated piece of political satire. So the dinosaur became the monarchy, an ideology that should be extinct; the hippos became the business interests, lining up to sniff the monarchy's rear; the pigs, the Maoists, in league with the monarchy to exclude the reasonable; the turtles, the international aid organizations, well intentioned but not a speedy breed; the elephants and ducks, carrying loads and doing laundry, the people; and the giraffes–as there are no giraffes in Nepal–the tourists, come to have a look. And across the top, a variation on Orwell: "All animals are equal, but some animals are more equal than others."

You can't tell a committee everything.

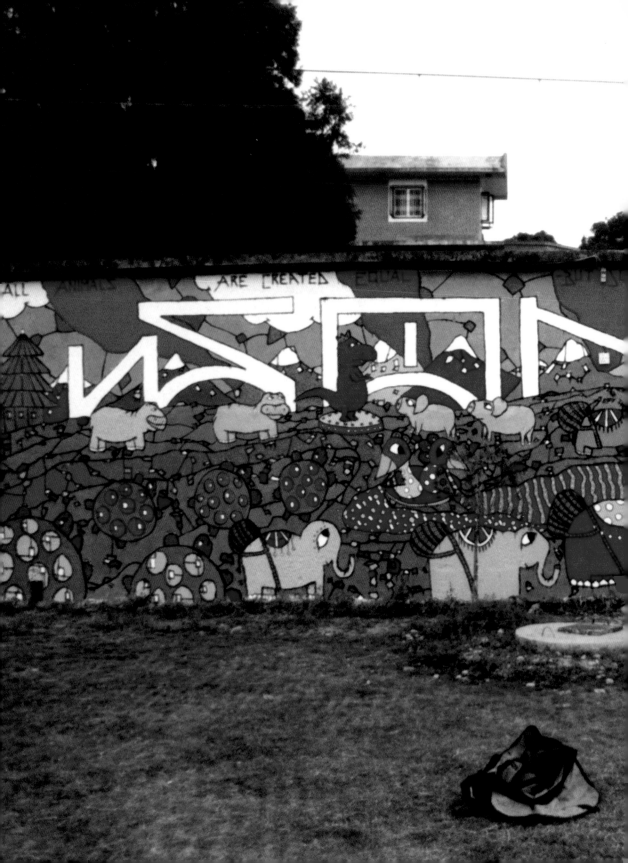

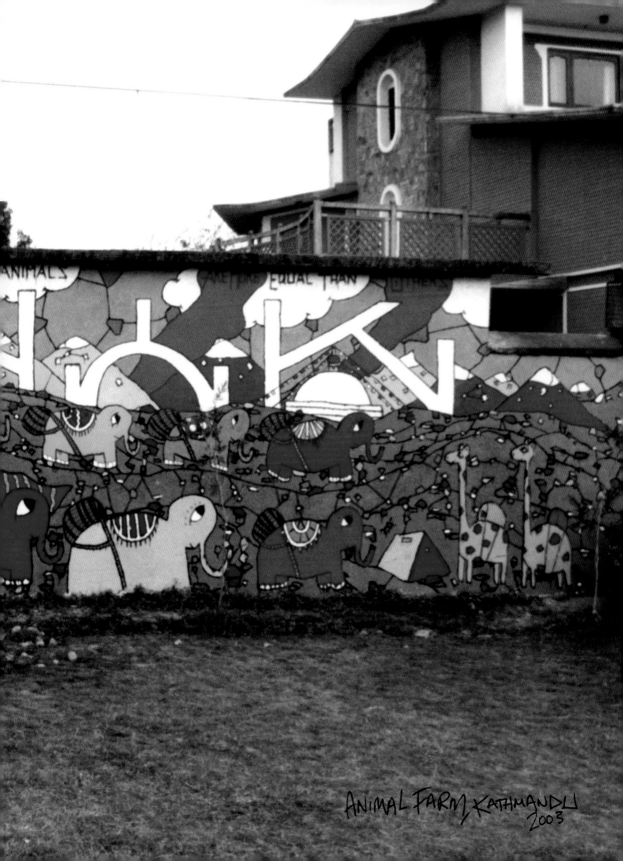

ANIMAL FARM KATHMANDU
2003

THE SPOT...

PAINTED M
2003
LALI'S HOU
THE ROAD-
SO ALTE
HIS WIFE AND
GOOD COC

SE YA GOT?

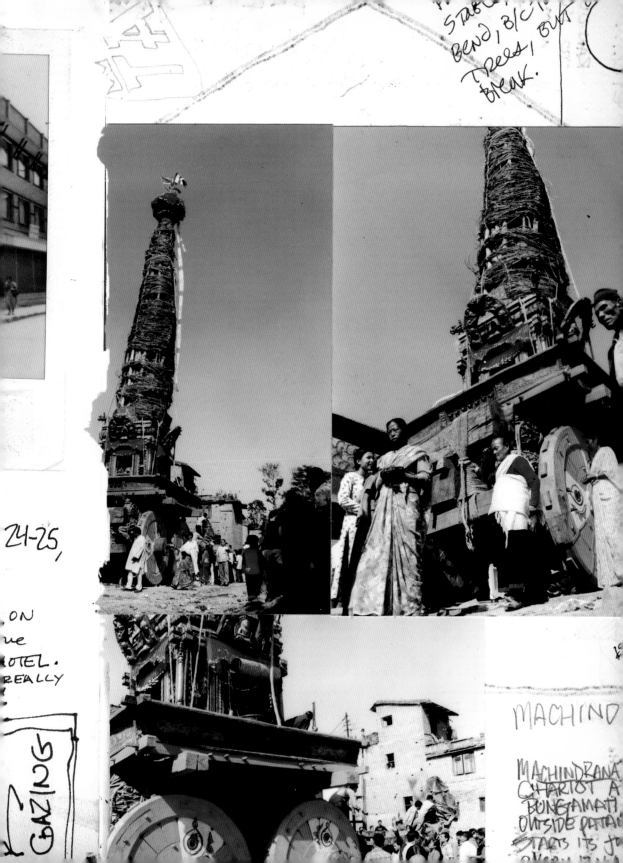

STARTS
BEND, B/C
TREES, BUT
BREAK.

24-25,

ON
ue
OTEL.
REALLY

GAZING

MACHIND

MACHINDRANA
CHARIOT A
BUNGAMATI
OUTSIDE PATTA
STARTS ITS J

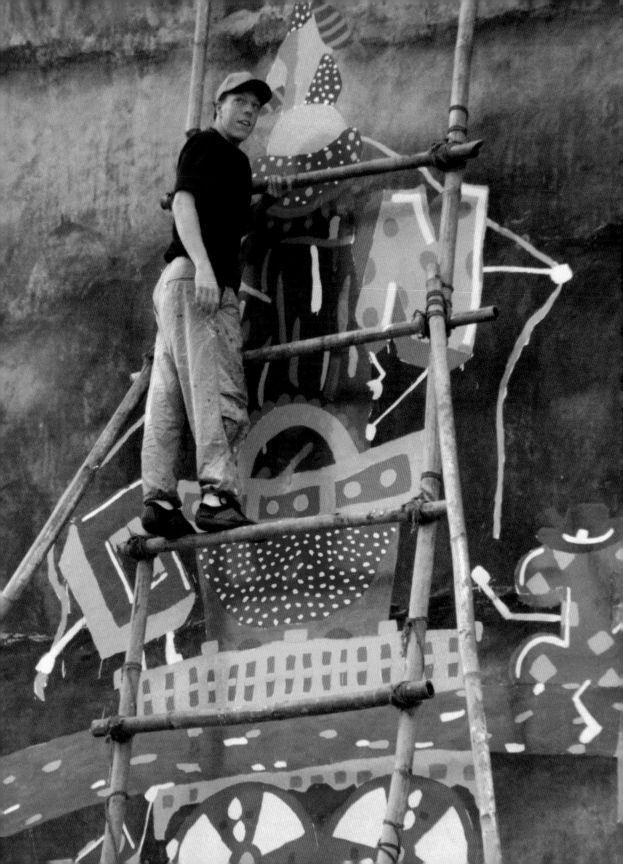

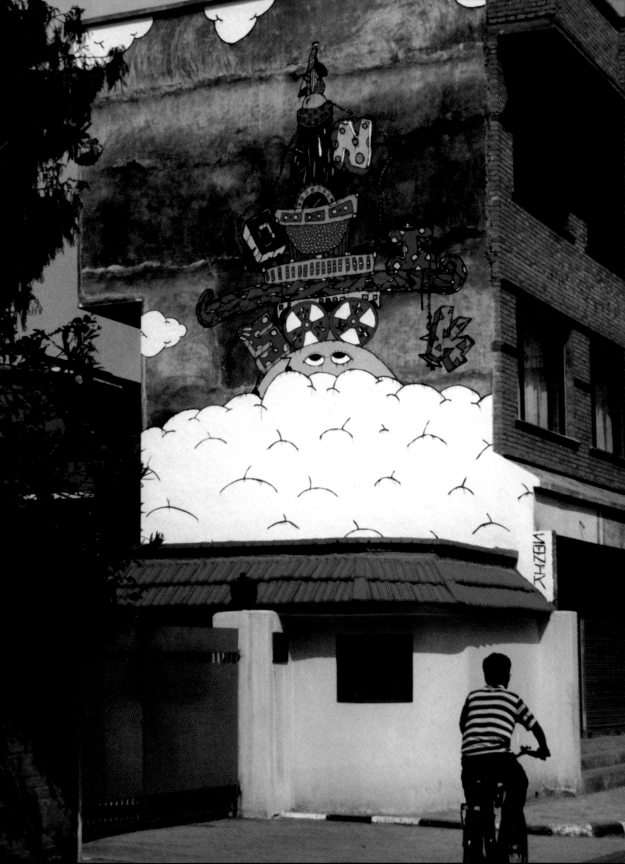

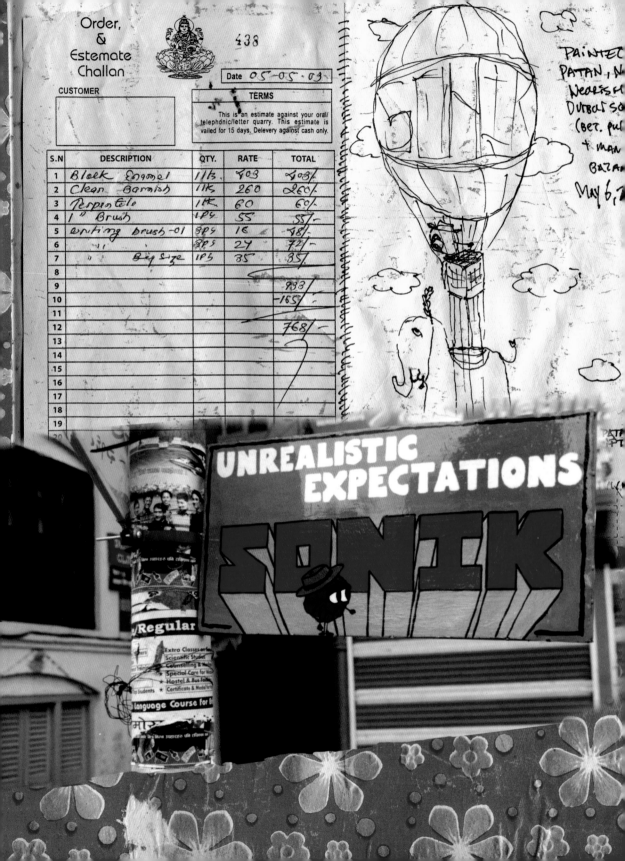

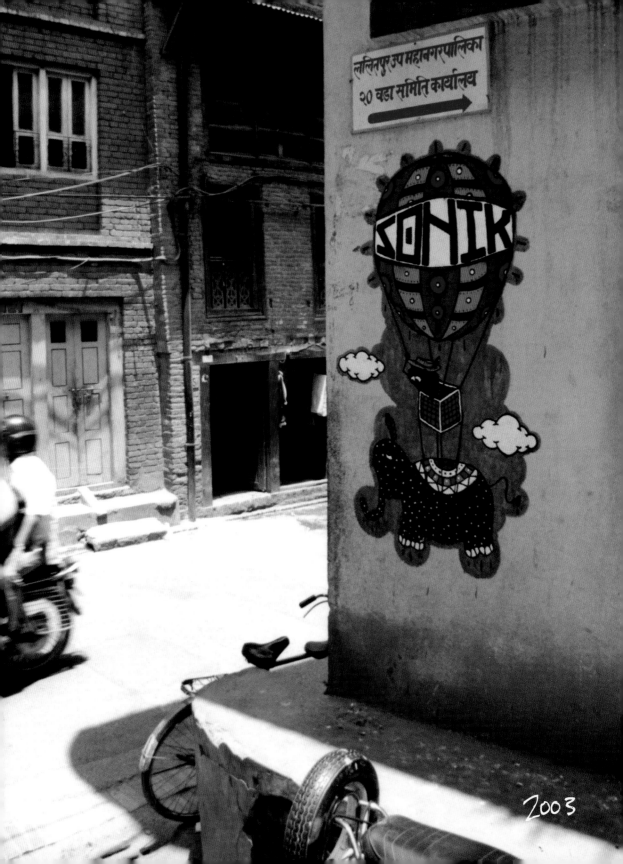

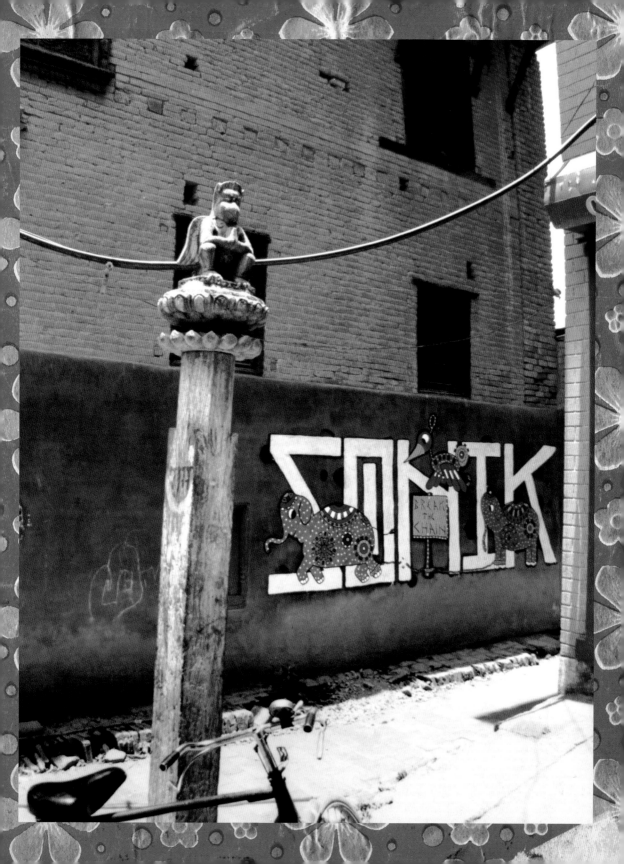

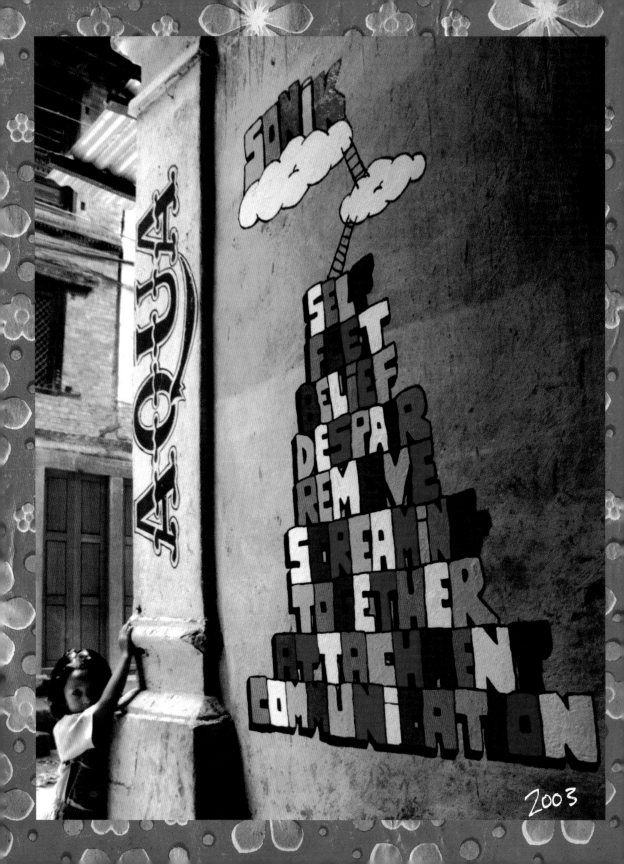

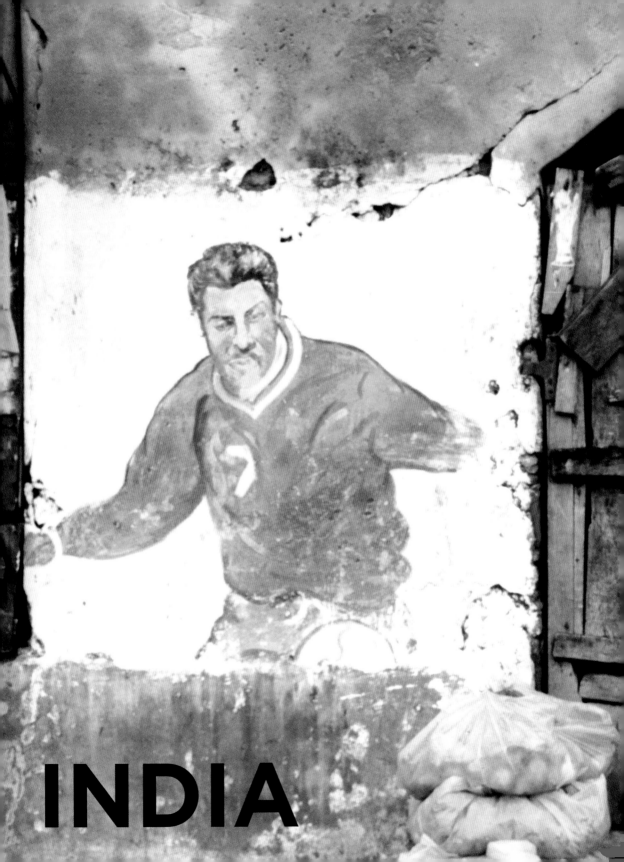

INDIA

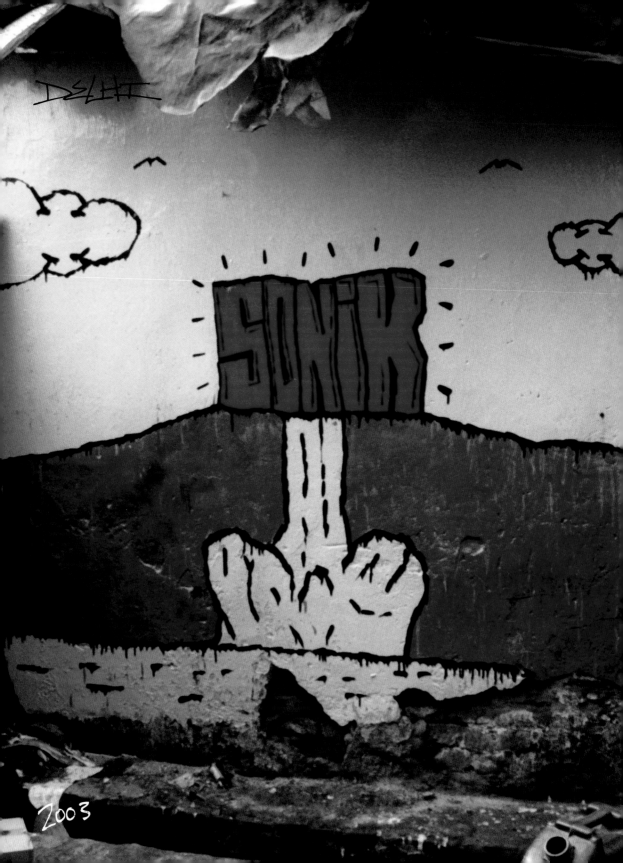

One of the worst paintings I've ever done.

Of course nobody wanted to travel to India with me. It was late June, and temperatures hit 120 before the monsoon hits. But it was when I could go.

Delhi is a city of 18 million, growing daily, and in the month of June it buckles under its own weight, with frequent power cuts stilling every fan and air conditioner and making everyone very short with one another.

Not far from where I stayed in Delhi was a starving artist colony, a small slum enclave of artists who had no steady employment and in some cases really were starving. One of my new friends in Delhi had spoken with some of the residents and had drummed up enthusiasm about my painting there. As I pulled off the main road, several men got into a fistfight over who would get to have their wall painted first. It was a bad sign.

Delhi is absolutely not a walking city. It has broad avenues, the result of British urban planning before they gave up the imperial dream in India. At times, these avenues have the feel of a big Texan city like Houston or Dallas; and in the government portion of New Delhi, they feel like Washington, D.C. Once one turns off these broad avenues and onto a side street, however, anything goes. The side street could turn out to be a leafy enclave of gigantic, walled estates, a middle-class neighborhood of rowhouses, or a slum.

I carried my bags of paint to the wall I was to paint, past a checklist of charity-commercial imagery: a dirt road with piles of waste; ditches on either side of the narrow dirt road, brimming with human excrement; houses consisting of a broken concrete wall and a collage of tarpaulins and corregated metal; little, naked children everywhere, covered with open sores and flies. It was seven in the morning and already over 100 degrees.

I knelt down to open my cans of paint, and a crowd formed around me, a tight semi-circle of people, about half of which were naked children. As I started to sketch out and fill in, two beat cops came walking down the path. Police in India carry long nightsticks, called lathis. The police cleared a gap in the crowd watching me by means of swinging these lathis. They hit the children. Hard. The police barked at me, "What are you doing here?! What is going on?!"

The sick thing about travel in India for me was how much it rewarded me for bringing out the worst parts of myself. I snarled back at the policemen with every bit of superiority that I could intone into my voice, telling them that I was painting a mural and that beating children was unacceptable. The police turned on their heels and walked on, looking embarrassed, and the children rubbed their lathi marks. I painted quickly, abandoning my more complicated ideas.

A stocky, strong woman rushed out of the shanty whose wall I was painting. She ran toward a girl of about seven or eight years old who was holding an infant and watching me paint. Catching the girl with her left arm, the stocky woman proceeded to hit her—and the infant—full force, over and over and over. The little girl took the blows with the breathless, tearless expression of a tiny body in the shock of receiving a beating that would have hurt a body three times her size. I wanted to vomit. My hands shook as I packed my paint and bags and took one of the most hurried photos of my life.

It was maybe 7:45 in the morning, and, luckily, the rest of India was doing much better.

CALCUTTA

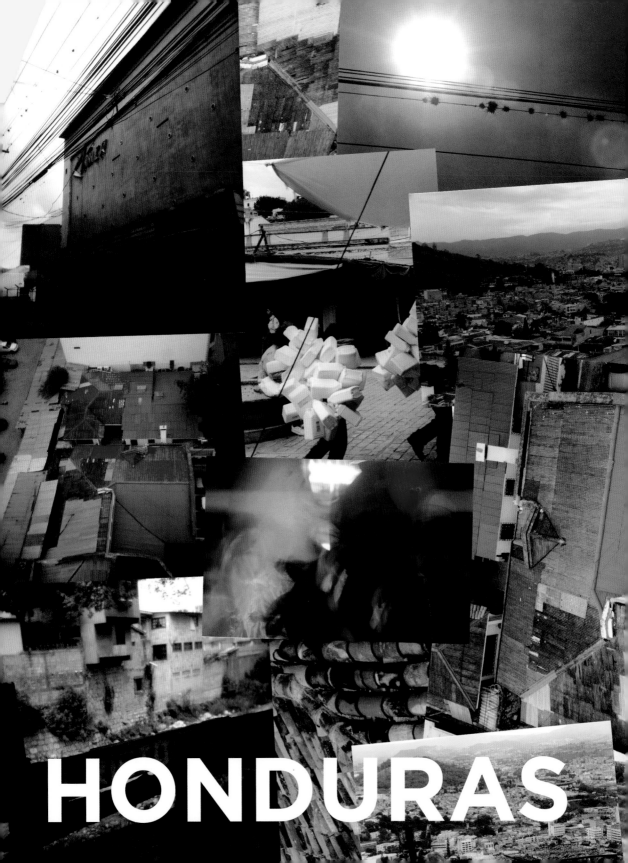

HONDURAS

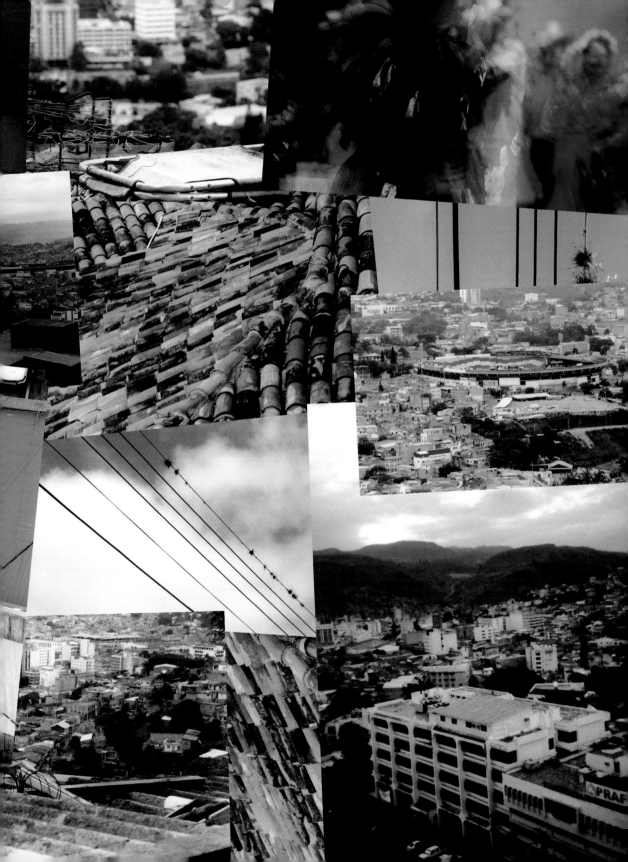

ay it with me. Tegucigalpa. Teh-goosey-galpa. It's fun to say. It was fun to tell my buddies that I was off to Tegucigalpa to go paint some murals. There was, and remains, a good reason to try a large-scale public arts project in Tegucigalpa, Honduras. While the city is reasonably livable and offers the amenities of classy restaurants and hotels, it is also–how do you say it without sounding awful?–uninspiring, especially when considered alongside other national capitals of similar size. It lacks the cultural resources that make for a sweet life, however financially impoverished it may be. I heard a number of well-traveled residents, whether expatriate or Honduran, begin their complaint about the city with: "It sounds terrible to say, but there's just no culture in Tegucigalpa at all!" So the UN Volunteers decided to bring in 50 artists from all over the world to do their thing. And how they picked me to get that email, I still have no idea.

One might assume that a city not known for culture would embrace the opportunity to have 50 muralists and sculptors come in from 20 countries and six continents and create large public works, especially when the entire project was funded by private money. But cities and countries that are accustomed to being culturally depressed tend to stay that way for good reason. Politicians who suspect that a joyful people will turn against them can purposefully aid and abet the spiral of cultural poverty. The position of Mayor of Tegucigalpa is a tradition-

a jumping-on point for the presidency of Honduras. Tegucigalpa is also the capital city of Honduras and the seat of government. Historically, this has meant that the president and mayor were de facto rivals, and the two would not cooperate on the project, however trans-partisan it might be. The First Lady was quick to support the idea, which guaranteed that the mayor of Tegucigalpa would do everything in his power to be an obstacle rather than an asset. Sculpture installation permits were mysteriously revoked at the last minute, municipal employees that were promised would fail to appear, and only by the organizers going over his head to the First Lady did these issues resolve.

In an effort to save face, the mayor organized a reception for our team of artists at City Hall. A functionary from his office handed us certificates of appreciation. Our group of artists and organizers sat on hard chairs and listened while the local Minister of Culture spoke, then were treated to a tedious PowerPoint presentation about the historic district of Tegucigalpa. The slight here was clear: the mayor had recently given the Minister of Culture his two weeks' notice prior to terminating his job permanently. The historic district, a large area of Tegucigalpa that manages to encompass much of the impoverished and desolate Comayagüela neighborhood, was entirely off-limits to the artists of the project, despite our insistence in working in particularly destitute areas of the city as

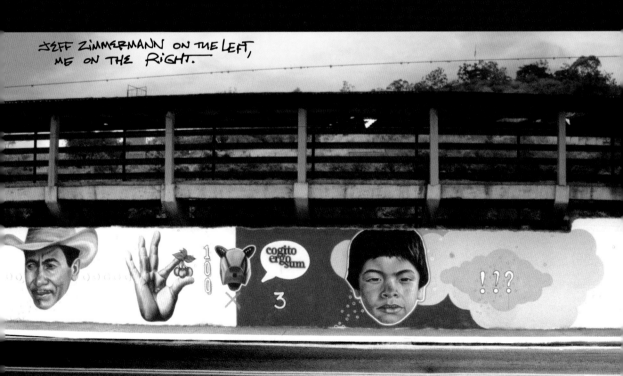

JEFF ZIMMERMANN ON THE LEFT, ME ON THE RIGHT.

well as those more affluent. The mayor himself did not show up.

Some days earlier, I sat on my scaffolding, three stories above the central quad of the national university. My large bull image was taking shape, when down on the quad a group of like-t-shirted American Southerners parked a freestanding five-foot cross down amidst their amplifiers. They plugged in their electric guitars and microphones, and proceeded to play competent Christian rock songs interspersed with staged skits in broken Spanish with an emphasis on going to hell. I dropped my paintbrush from my quivering hands, enraged and embarrassed for my country that this missionary group had traveled to Honduras to play and proselytize at a public university, an act that is prohibited in much of the United States. Such religious ideological incursions were common throughout Honduras. Americans on a flight to Honduras will find themselves amid a half dozen Hondurans and another hundred missionaries, invariably in matching t-shirts.

As a group of artists, we were certainly given thank yous and much appreciation from a great many Hondurans. Still, the trail of sponsorship in the case of this project led elsewhere. A Mexican company provided the paints. The marble arrived at the suggestion of the marble company owner's

Spanish-born wife. Many of the restaurants that offered meals to the artists were run by expatriates. The First Lady of Honduras herself was not Honduran. One could reason that because of the continual history of foreigners' exploitation of Honduras, there exists a well-founded resistance to further foreign involvement – perhaps even a numbness to the effects of foreign involvement, good or bad. This may well be the case, but the appreciation and gratitude of the Hondurans–those in a position to enjoy the art but not to sponsor it–said otherwise, rang genuinely, and gave us confidence as artists that we were doing the right thing. Unfortunately, that same line of justification–"Well, everyone tells us they love what we are doing"–is probably why the missionaries feel no compunction about proselytizing in Honduras in a way they cannot in the United States. It would certainly make me feel better to keep art at a philosophical arm's length from religion. But in the end, what can art be except for an endless string of value judgments: that a wall would look better with my mural on it; that a certain color should go in the middle; that an image should be a certain size; and so on. Maybe in the end, we decide that confidence in our own value judgments is all it takes to have faith in what we do, and that painfully, like the missionaries I found in such poor taste, faith and confidence is all that is needed.

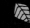

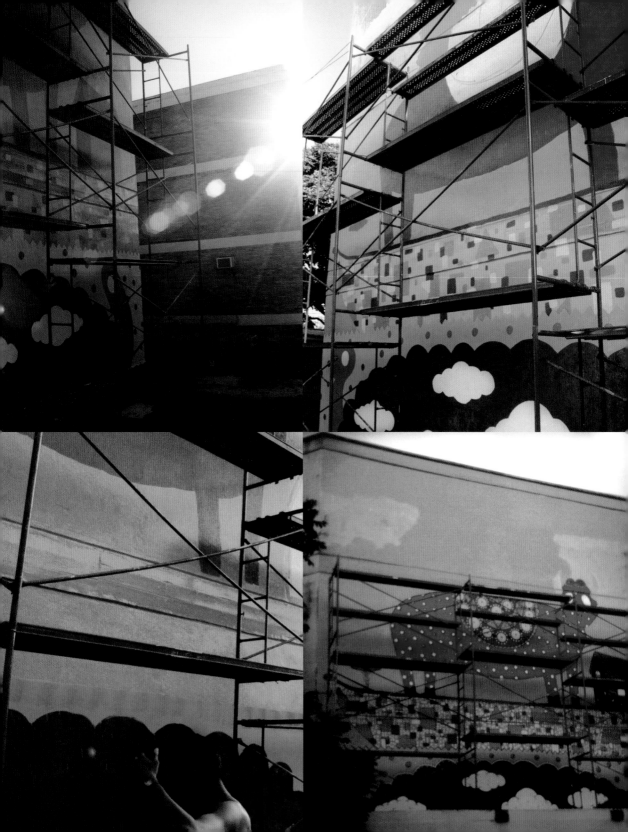

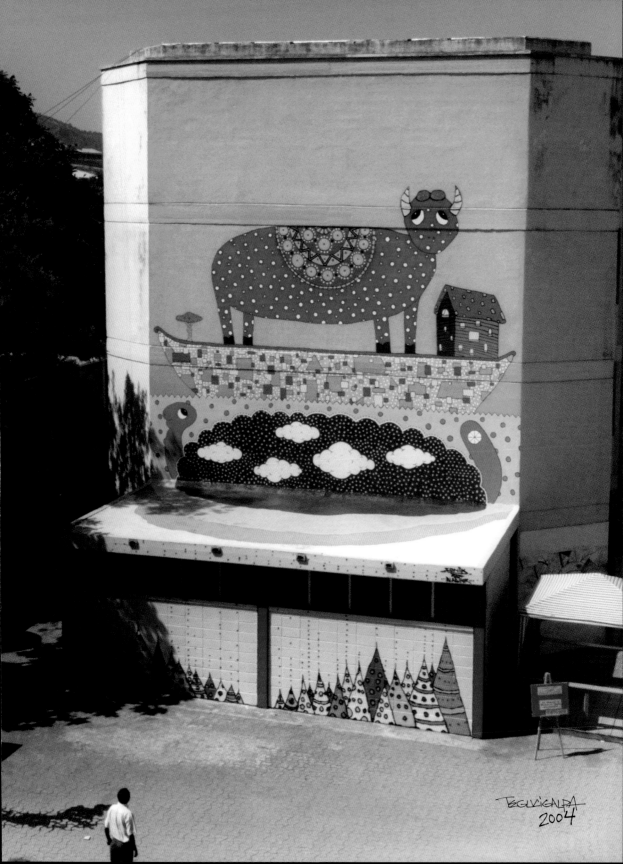

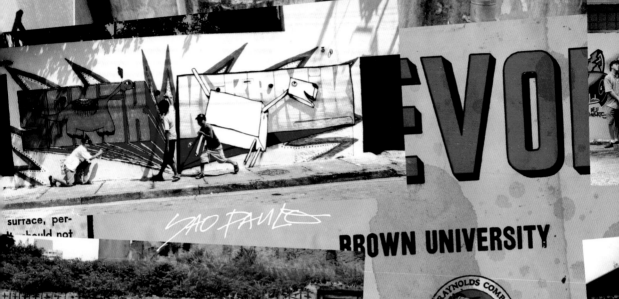

EVOI

surface, per-
should not

SAO PAULO

BROWN UNIVERSITY

EVOE & RAYNOLDS COMPANY, INC
FOUNDED 1754

VENDE
285-5799
ORA LOU
NDE
9515
NDE
2381

SONIK

SK-1
CREW

#1 SONIK 3000

ARD GAUON

FEDERAL BLUE
8-18650

DEVOE & RAYNOLDS COMPAN

SONIK

KATHMANDU

BOSTON

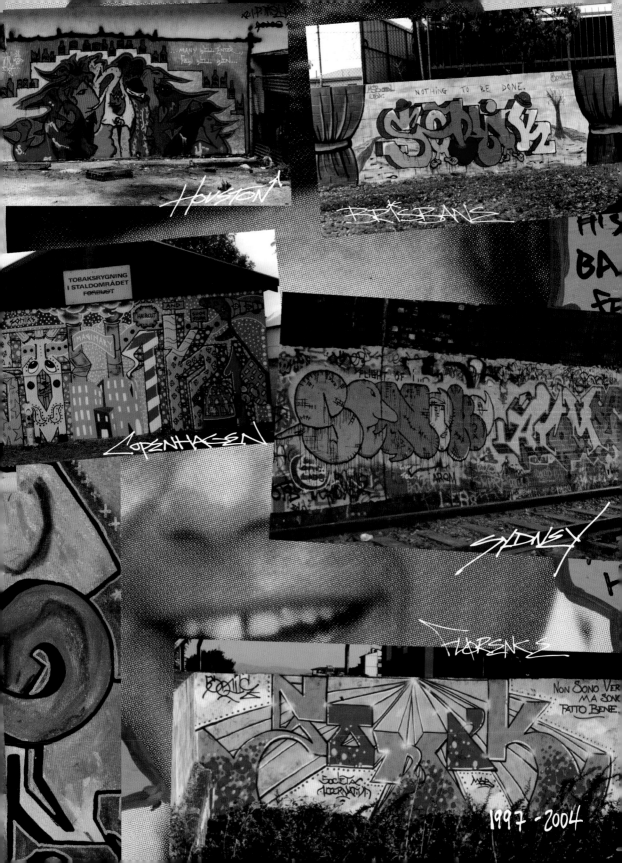

HOUSTON

BRISBANE

NOTHING TO BE DONE.

MANY WILL ENTER,
FEW WILL WIN...

TOBAKSRYGNING
I STALDOMRÅDET
FORBUDT

COPENHAGEN

SYDNEY

FLORENCE

NON SONO VERI
MA SONO
FATTO BENE.

1997 - 2004

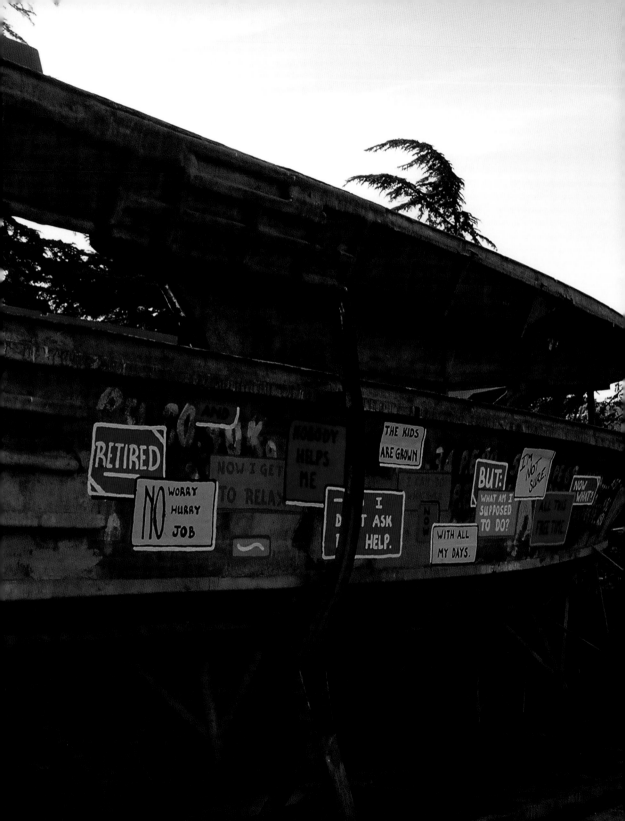

ISTANBUL
2.006

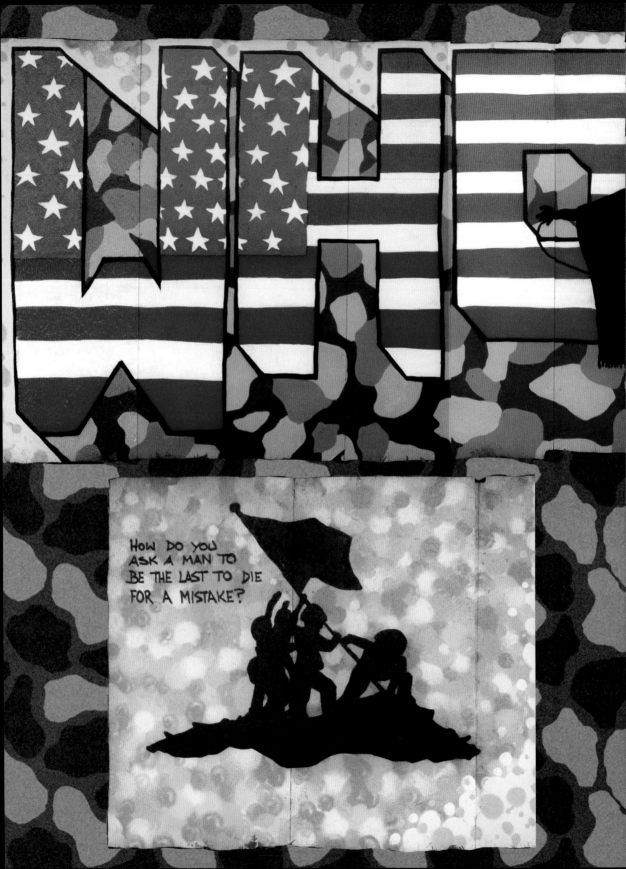

HAVE YOU NO SENSE
OF DECENCY, SIR, AT
LONG LAST?

DENMARK
2004

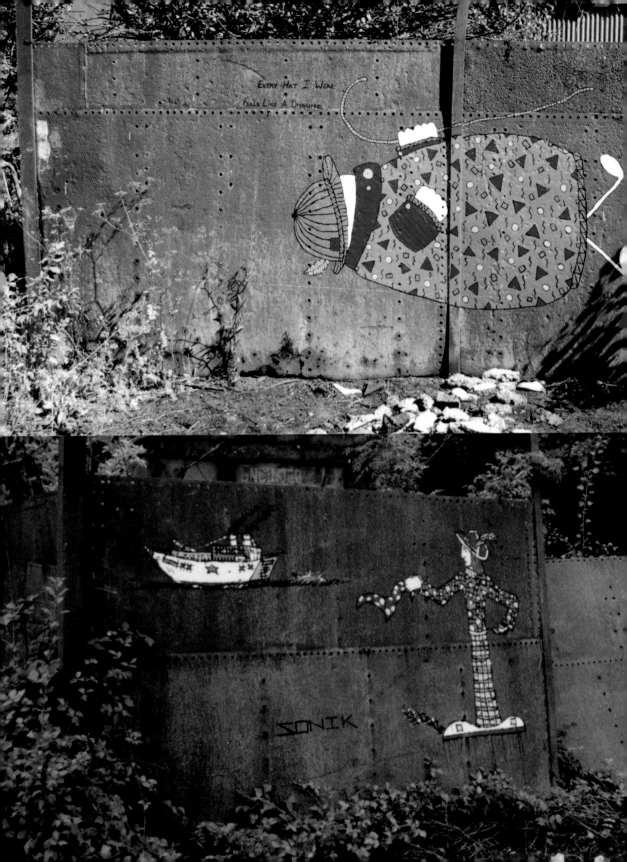

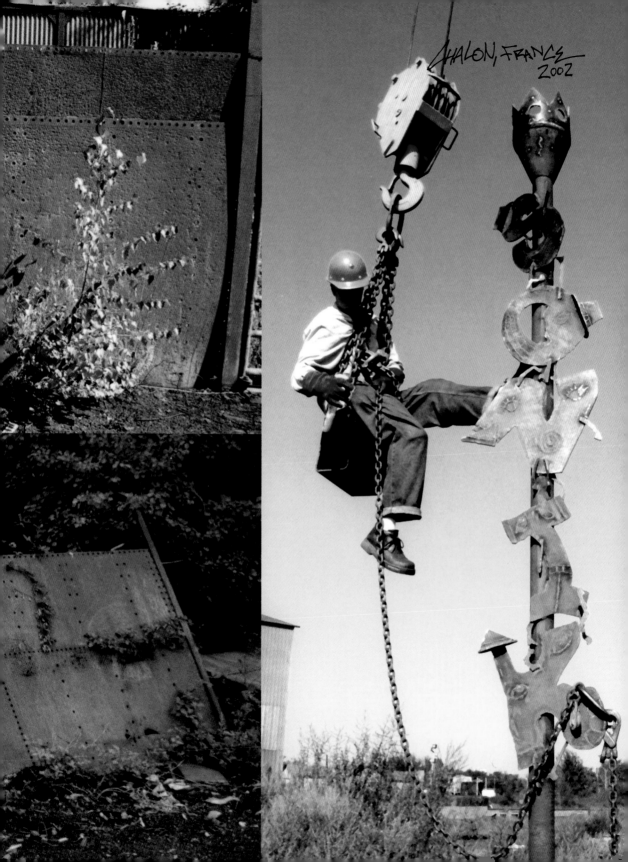

CHALON, FRANCE
2002

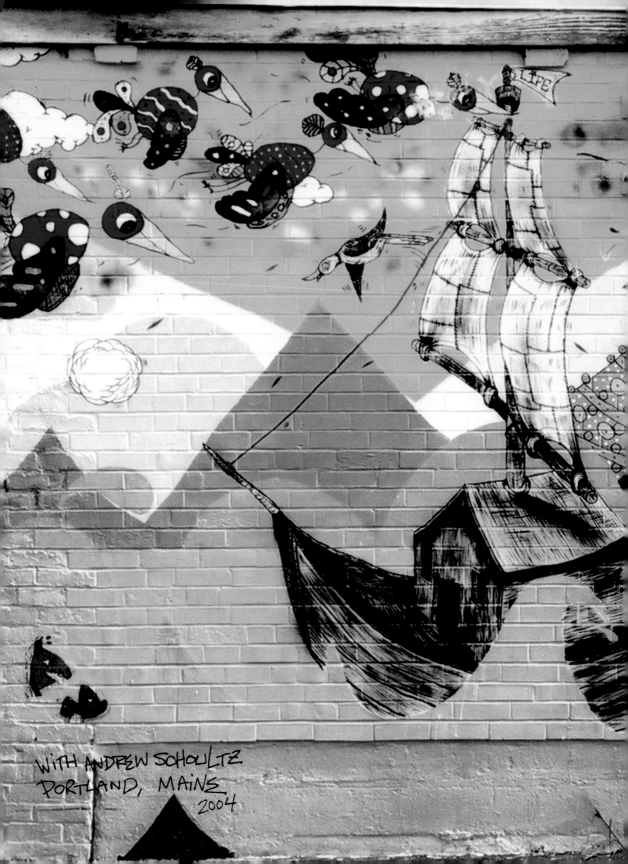

WITH ANDREW SCHOULTZ
PORTLAND, MAINE
2004

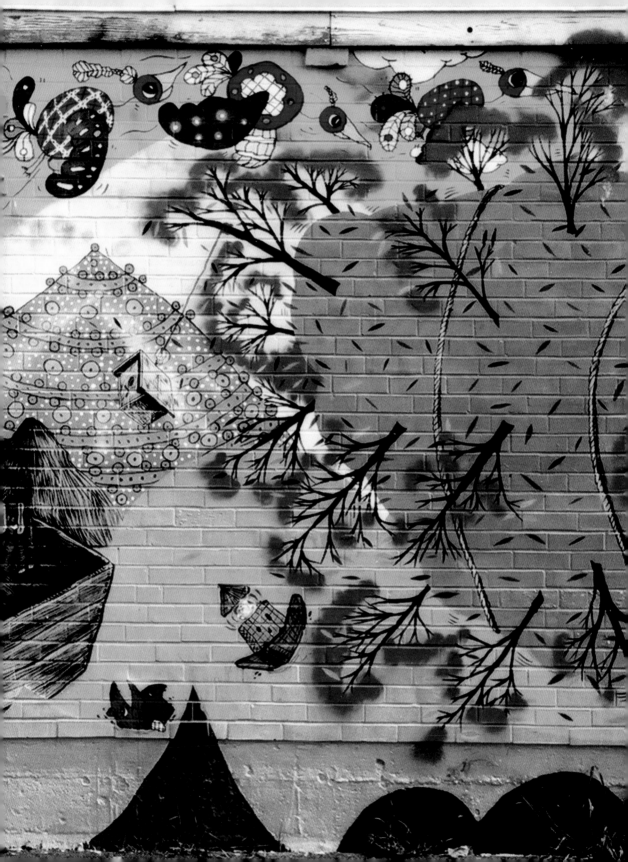

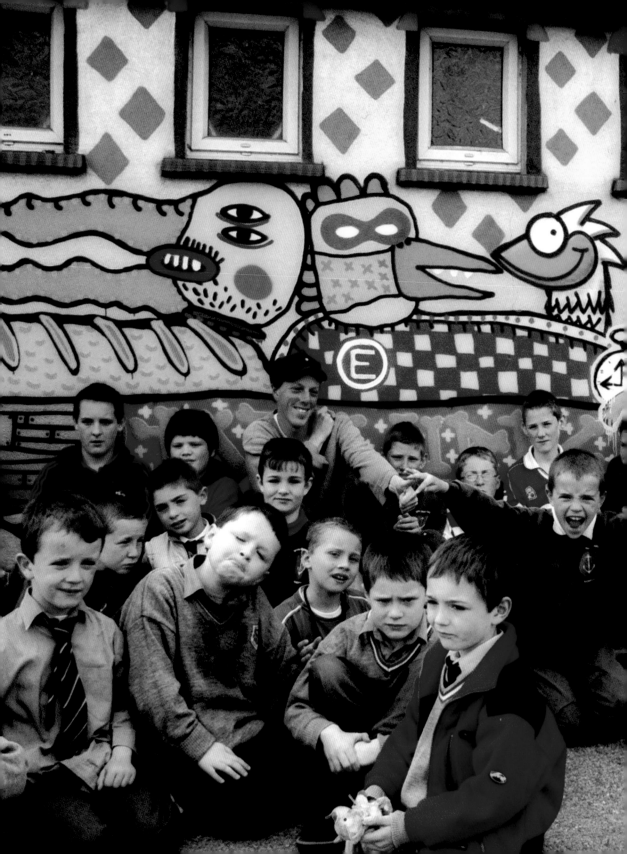

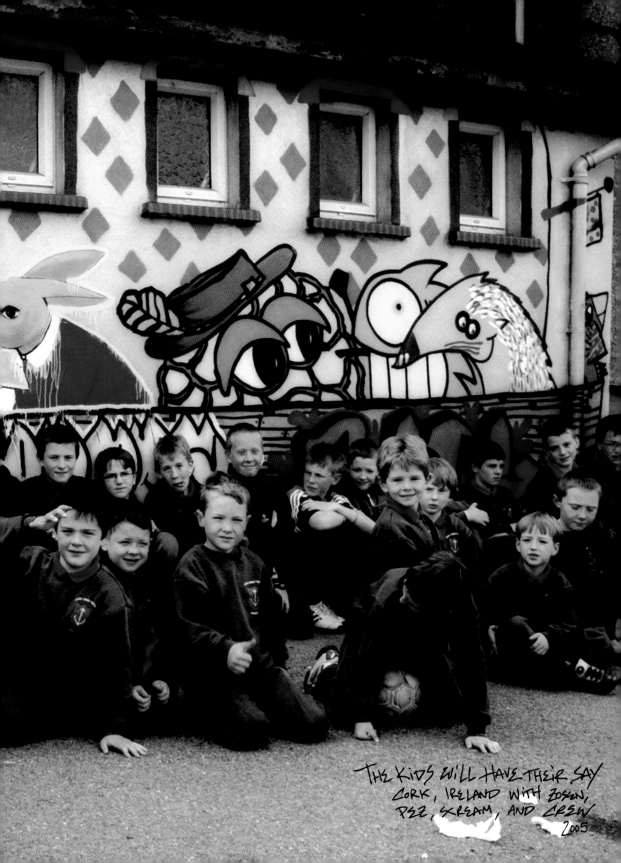

THE KIDS WILL HAVE THEIR SAY
CORK, IRELAND WITH ZOSEN,
PEZ, SKREAM, AND CREW
2005

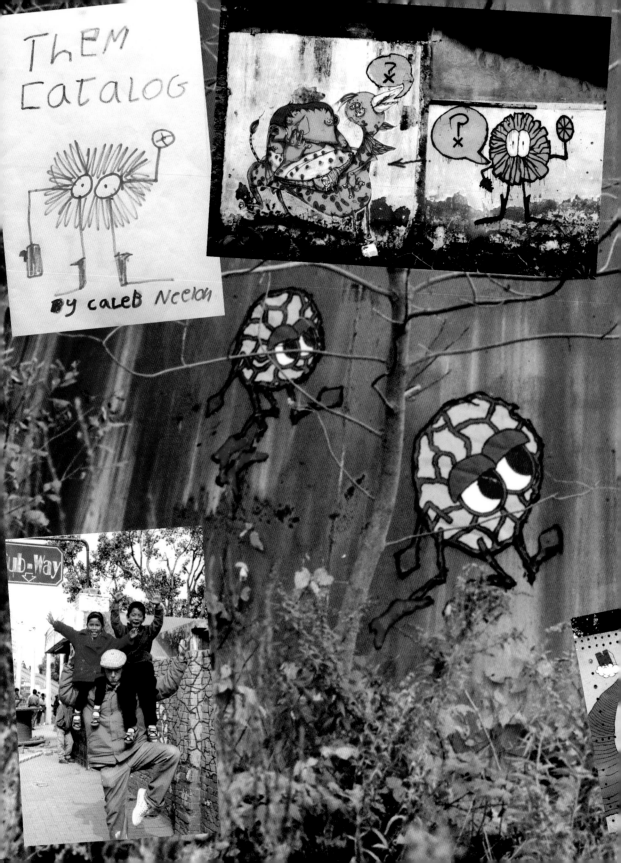

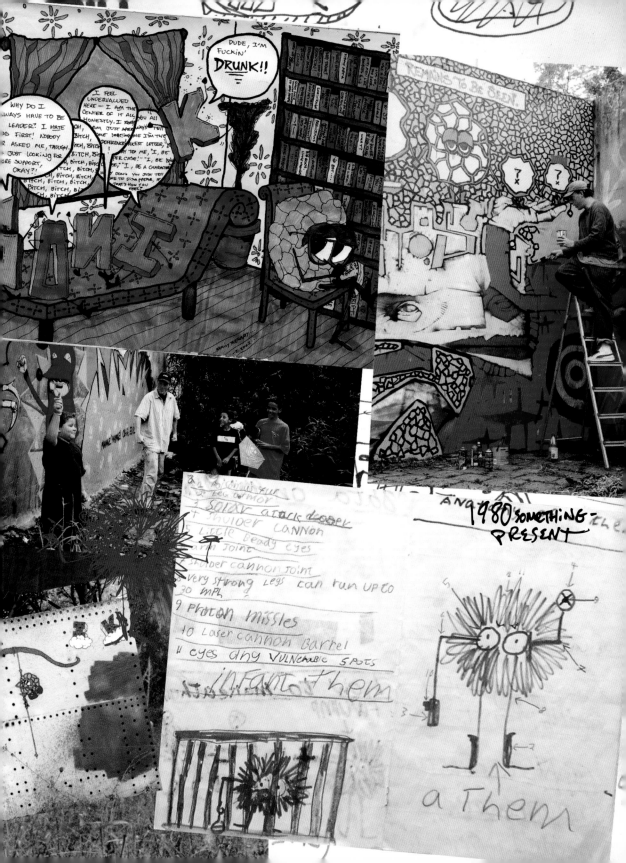

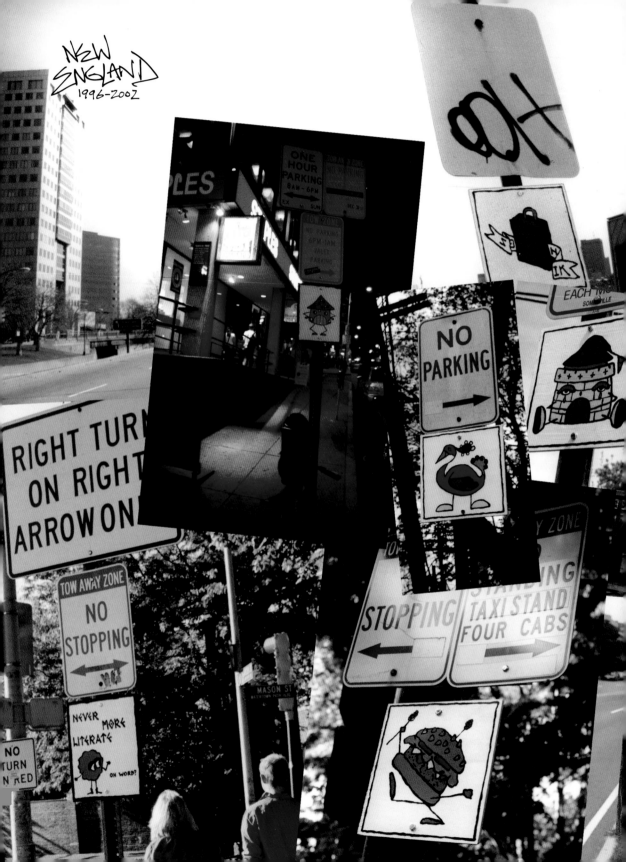

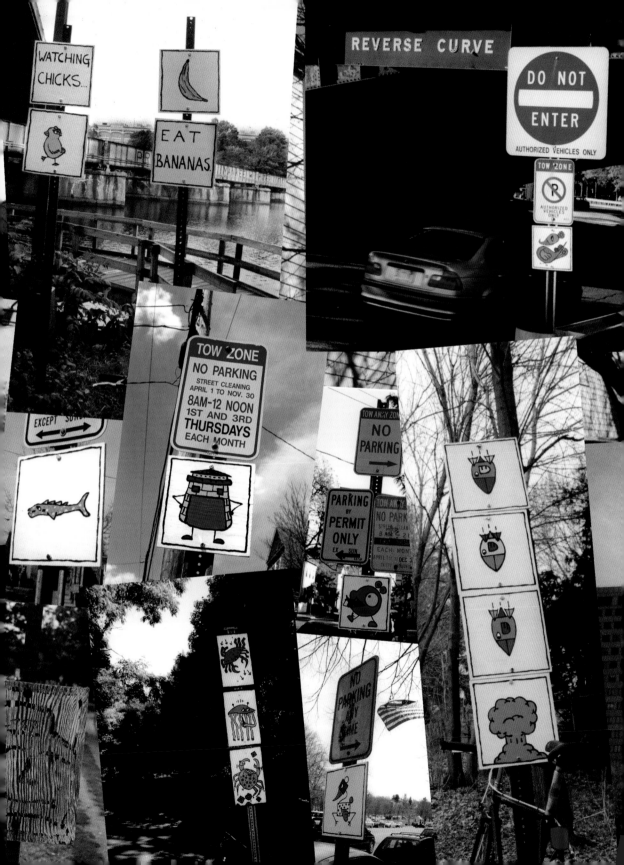

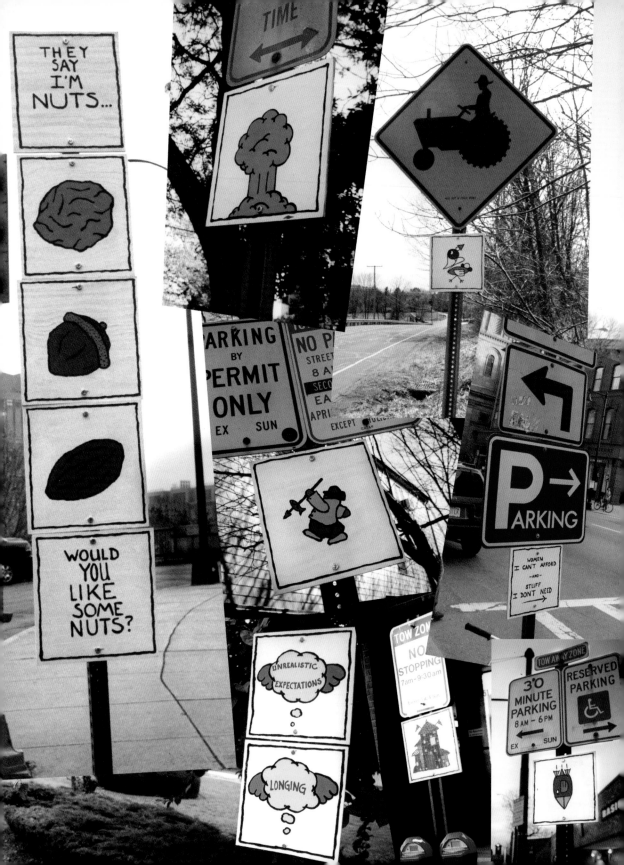

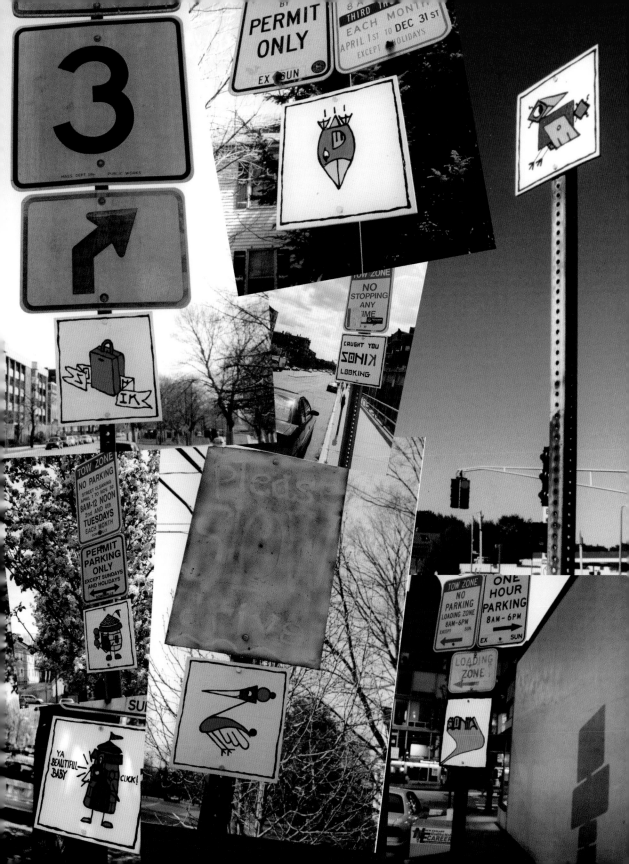

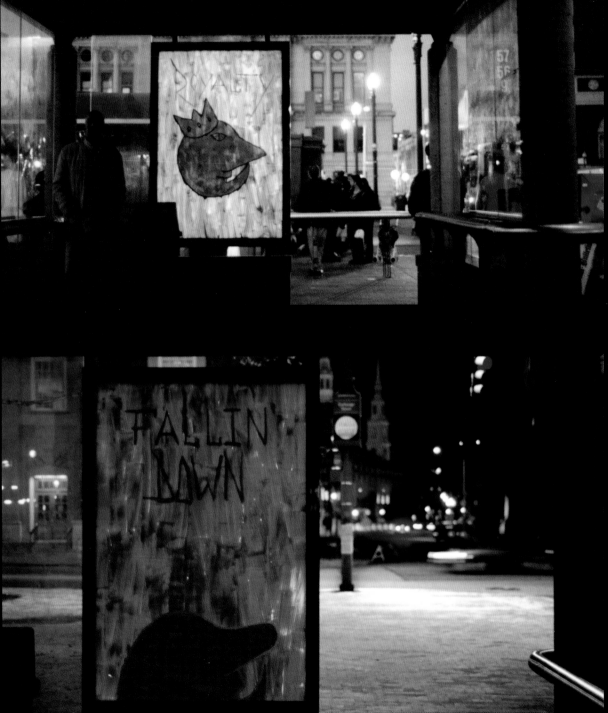

Revolving Museum,
Lowell, Mass. 2004

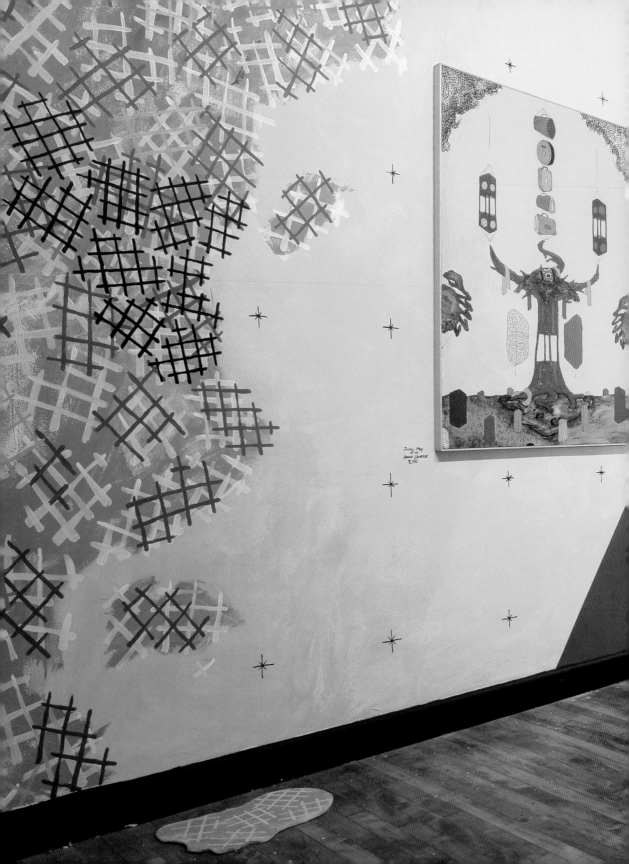

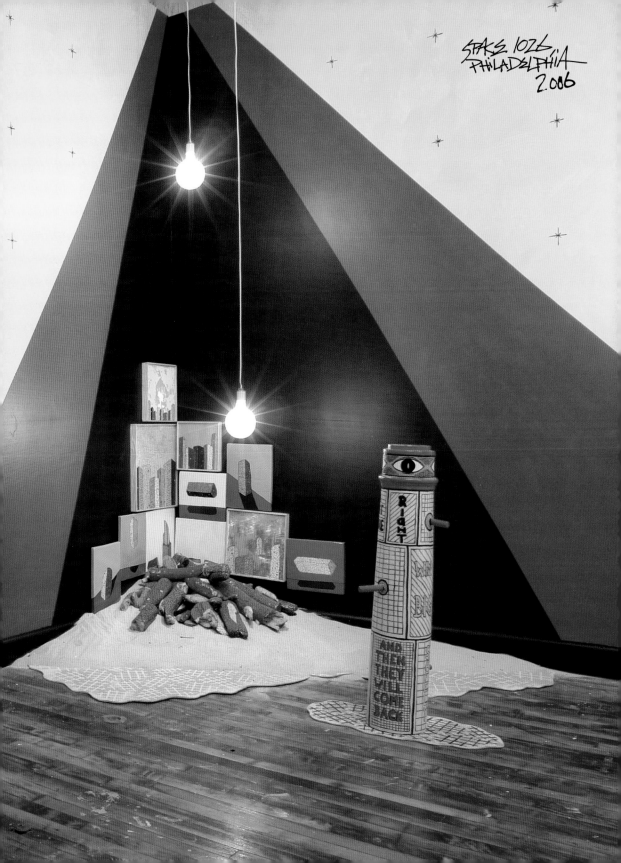

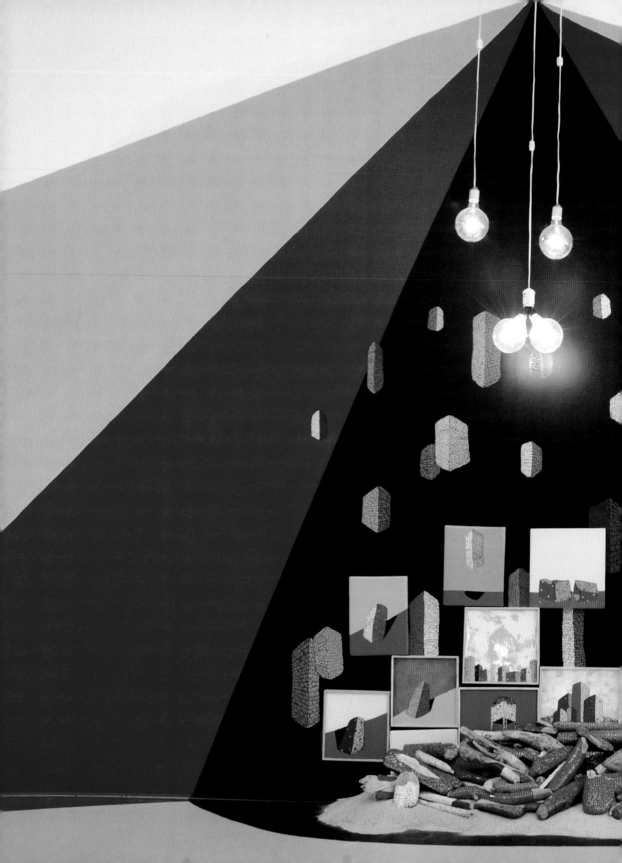

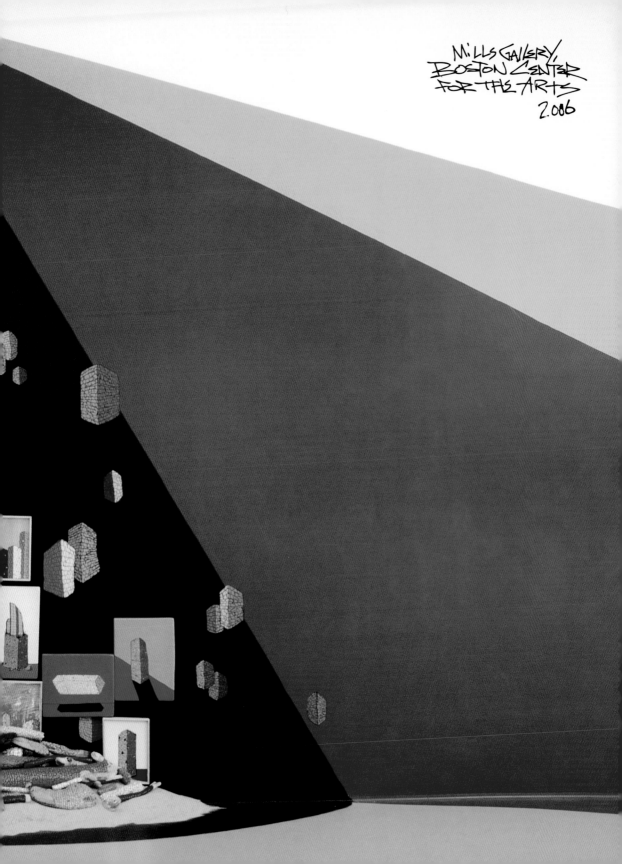

MILLS GALLERY,
BOSTON CENTER
FOR THE ARTS
2.006

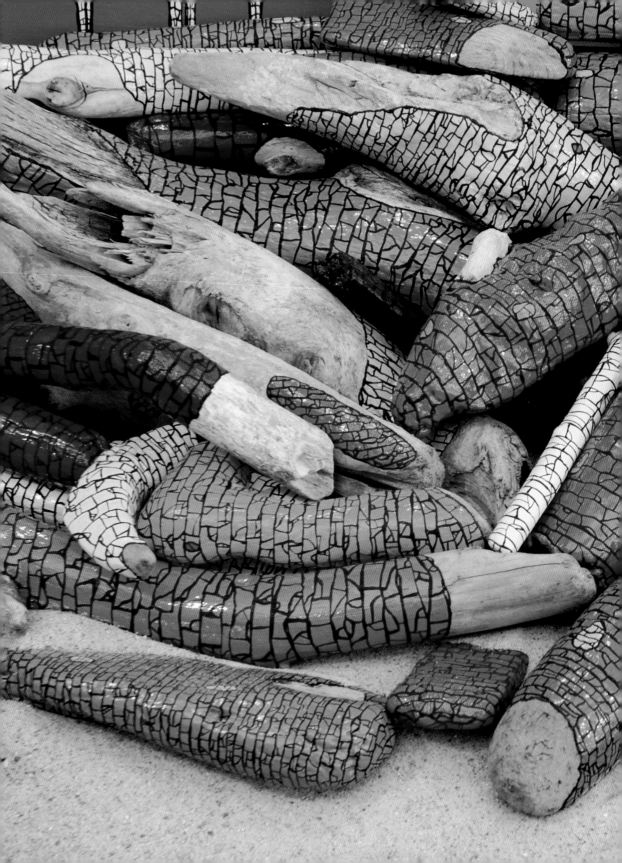

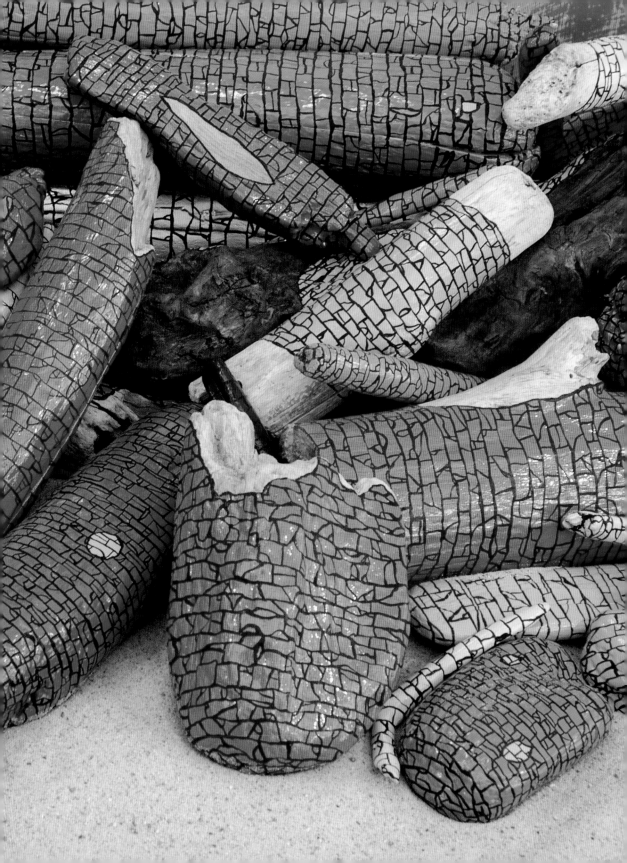

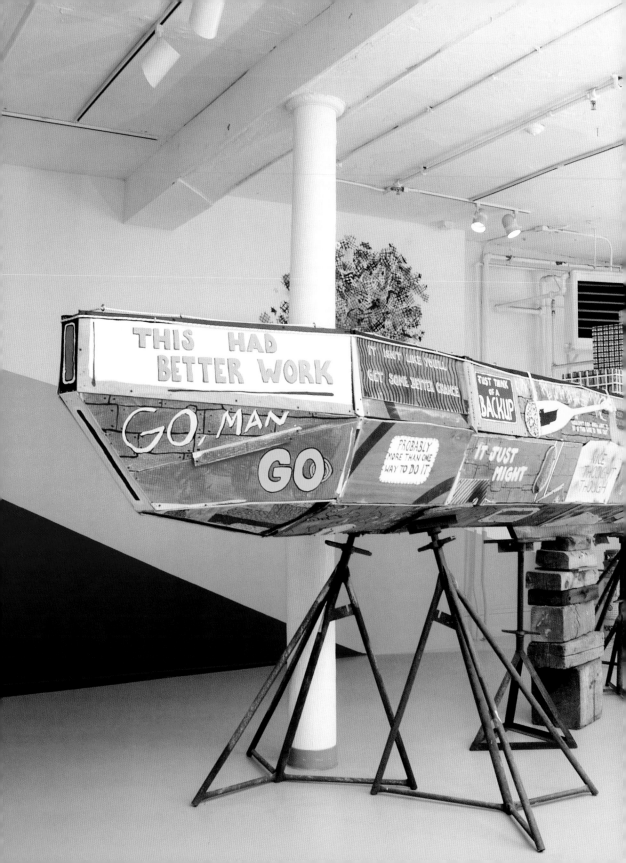

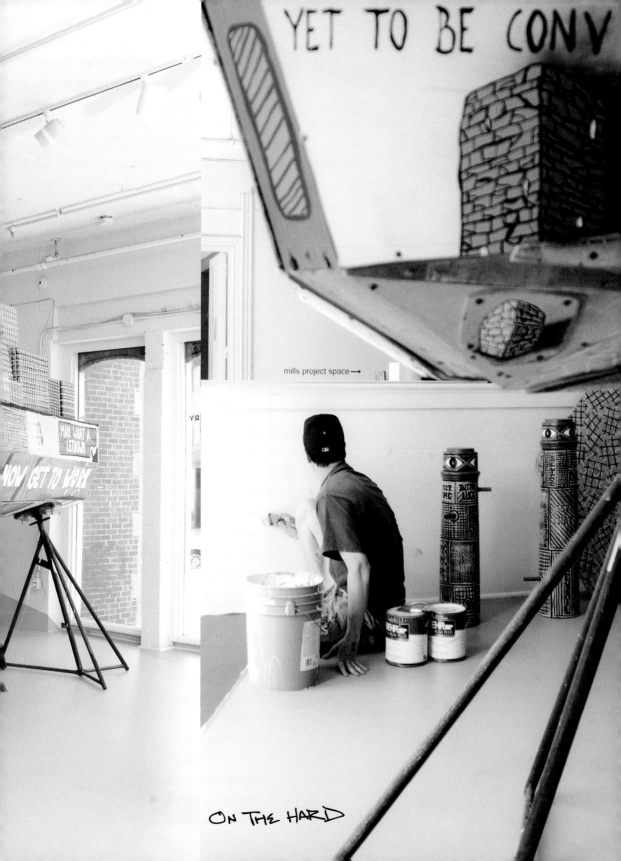

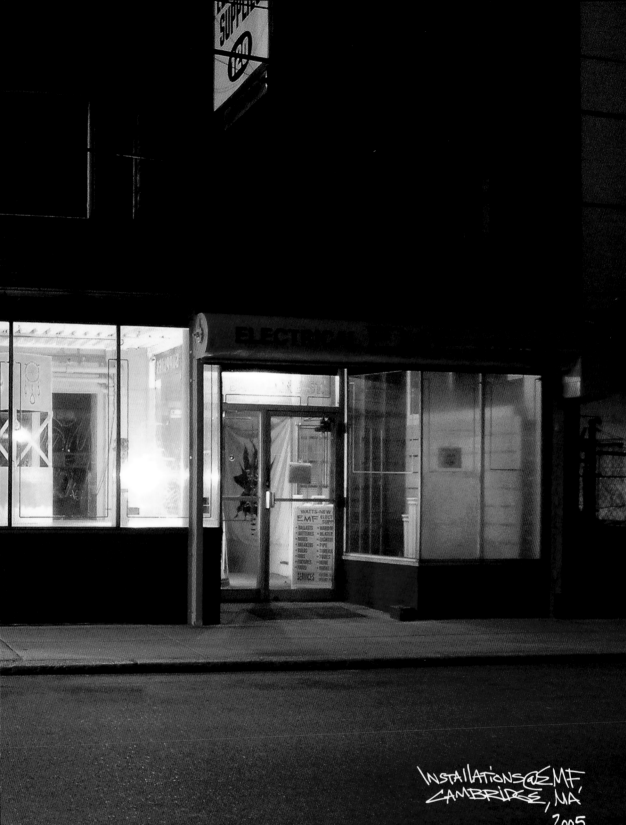

INSTALLATIONS@EMF.
CAMBRIDGE, MA.
2005

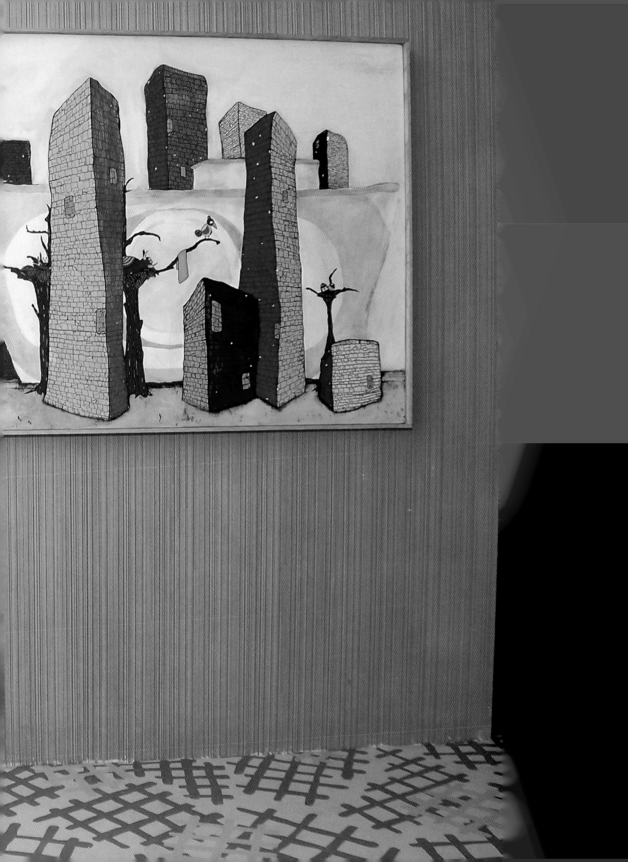

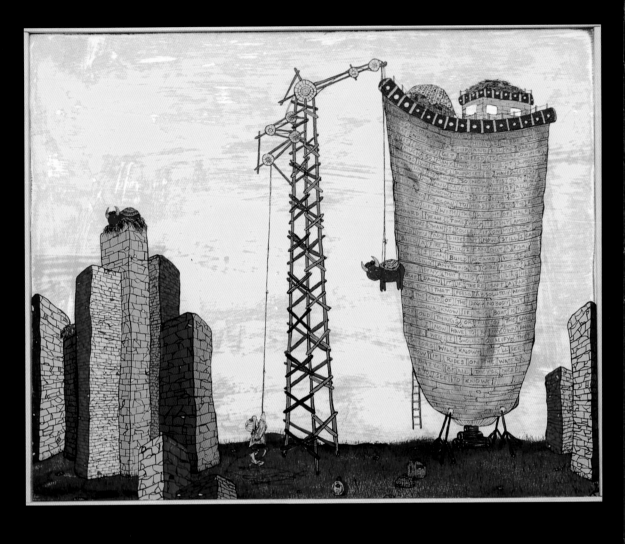

Divorce Ark 2.006

Never used to need the ship. Was once it all fit on my back, everything I needed. Now what, now it's a ship, and I'll be darned if it doesn't get stuffed to overflowing. So much, so many things to fill it, supposedly things we were supposed to have needed, have had to have. So now it's just me, huh – me and my little half of all our crap. You know what? Keep what you want. I've no reason to head off to the rest of my life with the weight of half a hoard. Yeah. Time was it didn't amount to more than I could fit on my back, and it's no different now. Still I can build a fire, still I can gut a fish, still I can build a camp. Will I even be losing anything I care about? I can't deny that this hurts like hell be my own damn self. Well, I should qualify. The sailors will know. They'll see how it rides on the water. That'll be all they'll need to see to know.

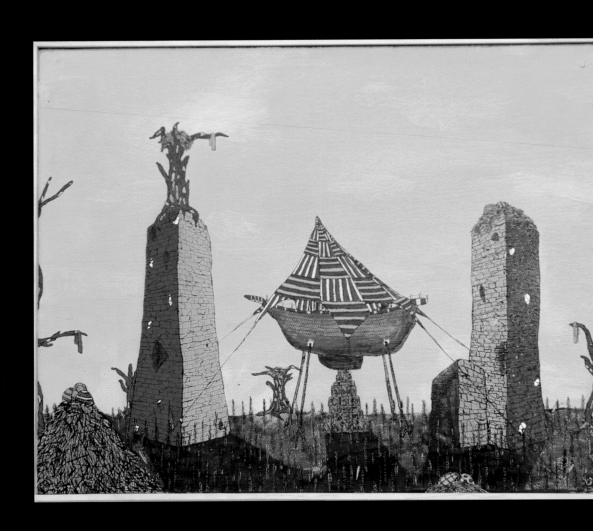

WINTERIZED 2005

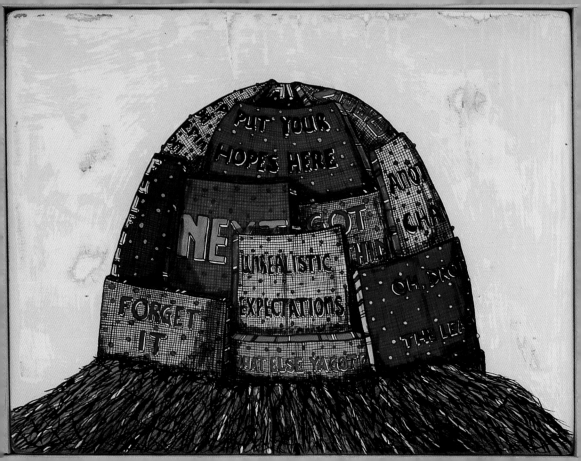

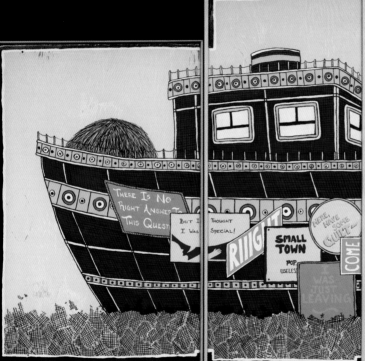

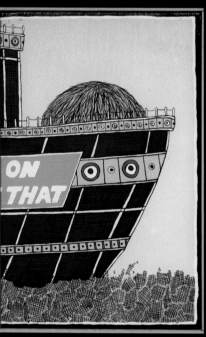

PUSHMEPULLYOU,
A MEDITATION ON
LEAVING HOME
2005

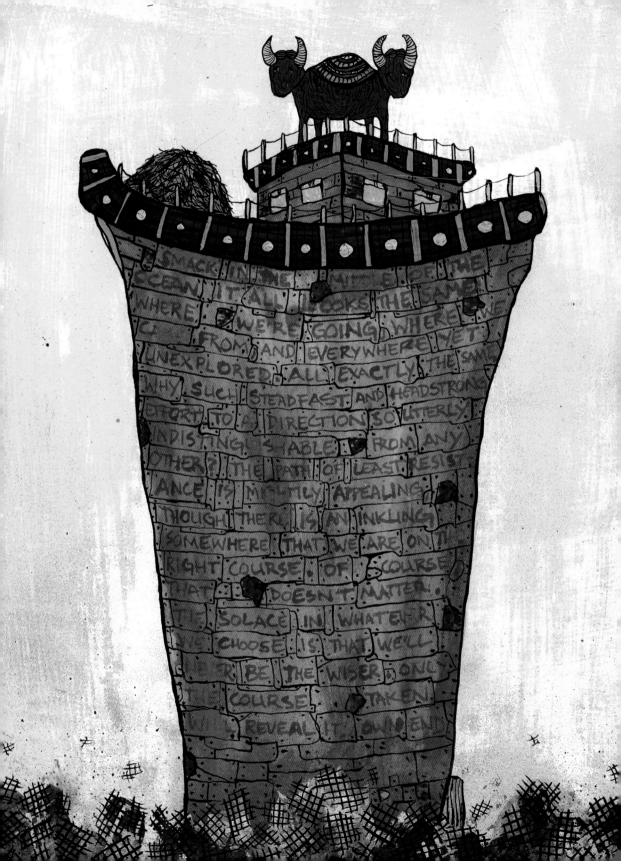

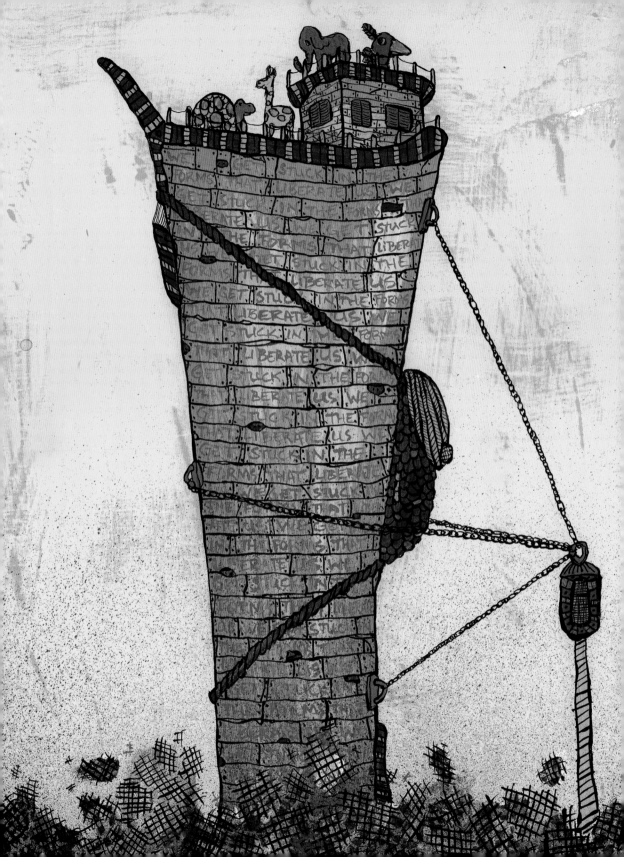

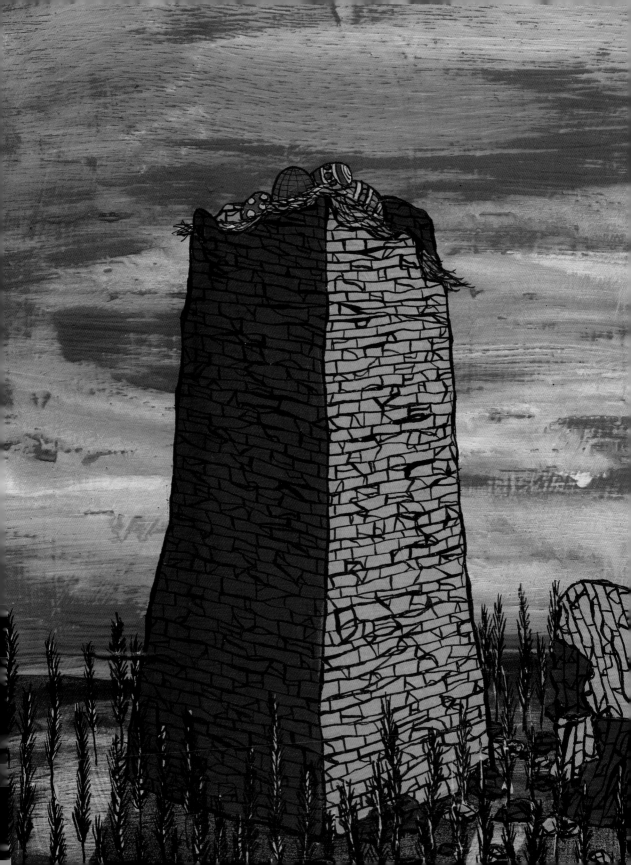

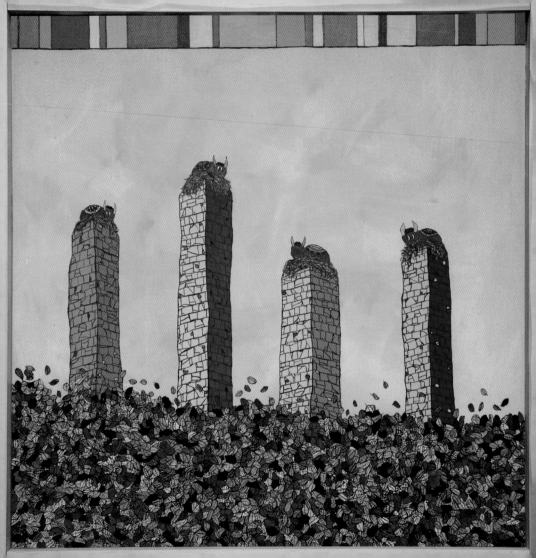

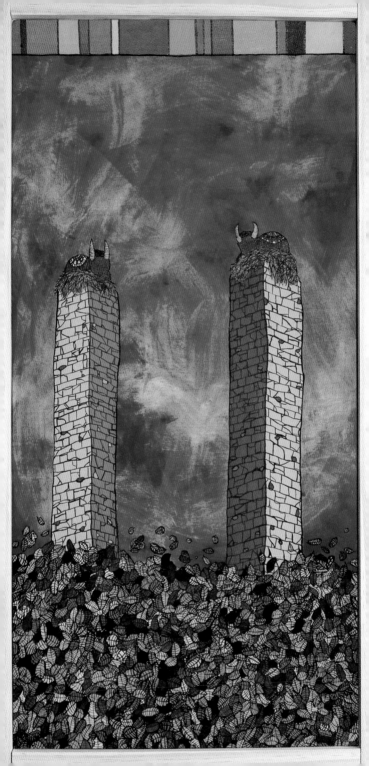

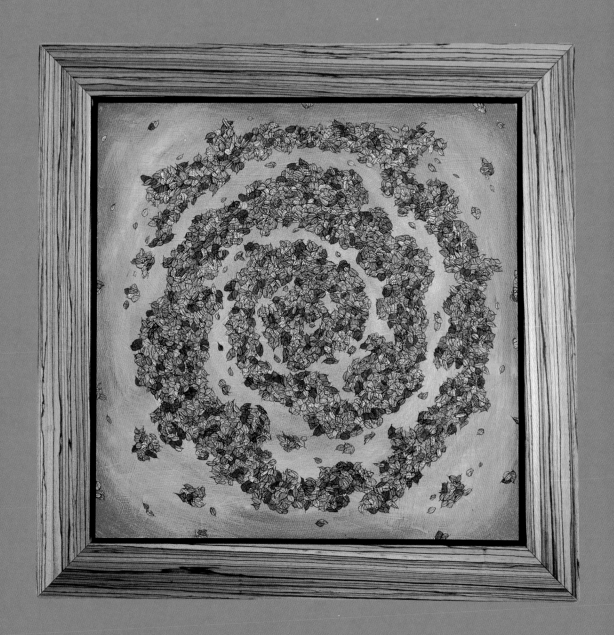

Faithful Id 2005

Their creation story was a total lie and they all knew it. In the face of overwhelming faith, they just couldn't bear the thought that the letter of their law would be so thoroughly contravened by their own efforts put forth in their celebration of curiosity and mystery. Funny thing about freedom, that, the more a world allows for it, the more it demands of the rein-holders, however lightly it may be that they restrain their charges. And with that fulfilled curiosity came anger, of course, especially at the custodians of the faith, who, as it turned out, were stuck selling lies in a market in which they were to be utterly punished for the sale of anything else. That pesky fact wouldn't turn them back – there would always be a new way to sell salt to the ocean.

*Trouble was, someone had gotten there first.

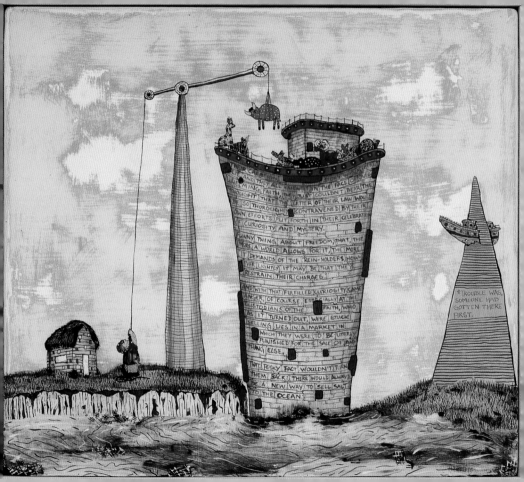

...AND THEY ALL LAID IN THE FACE OF MINGLED FAITH, THAT JUST COULDN'T BEAR THE THOUGHT THAT THE LETTER OF THEIR LAW WAS SO THOROUGHLY CONTRAVENED BY THEIR OWN EFFORTS PUT FORTH IN THEIR CELEBRATION OF CURIOSITY AND MYSTERY.

FUNNY THING ABOUT FREEDOM, THAT, THE MORE A WORLD ALLOWS FOR IT, THE MORE IT DEMANDS OF THE REIN-HOLDERS, HOWEVER LIGHTLY IT MAY BE THAT THEY RESTRAIN THEIR CHARGES.

AND WITH THAT FULFILLED CURIOSITY CAME ANGER, OF COURSE, ESPECIALLY AT THE CUSTODIANS OF THE FAITH, WHO, AS IT TURNED OUT, WERE STUCK SELLING LIES IN A MARKET IN WHICH THEY WERE TO BE LITERALLY PUNISHED FOR THE SALE OF ANYTHING ELSE.

THAT PESKY FACT WOULDN'T TURN THEM BACK: THERE WOULD ALWAYS BE A NEW WAY TO SELL SALT THE OCEAN

*TROUBLE WAS, SOMEONE HAD GOTTEN THERE FIRST.

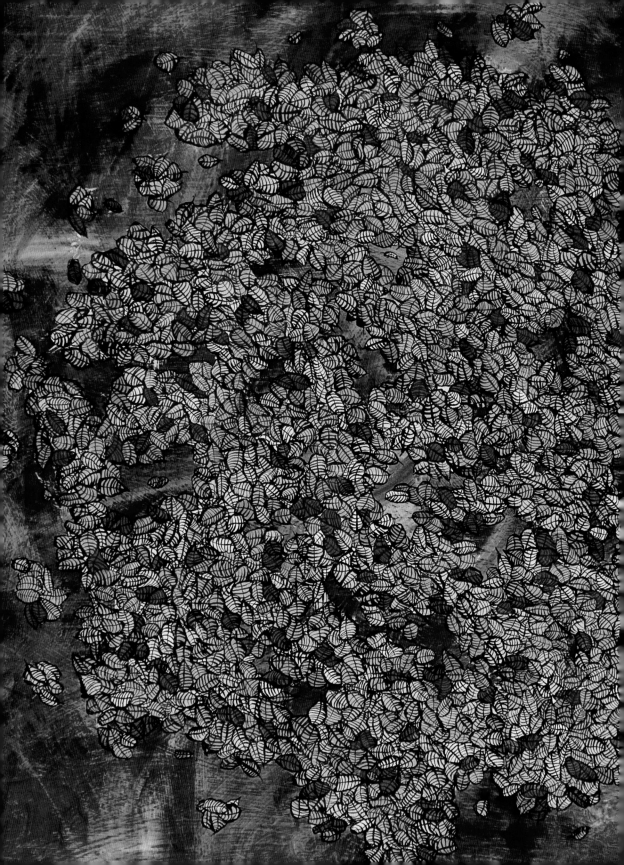

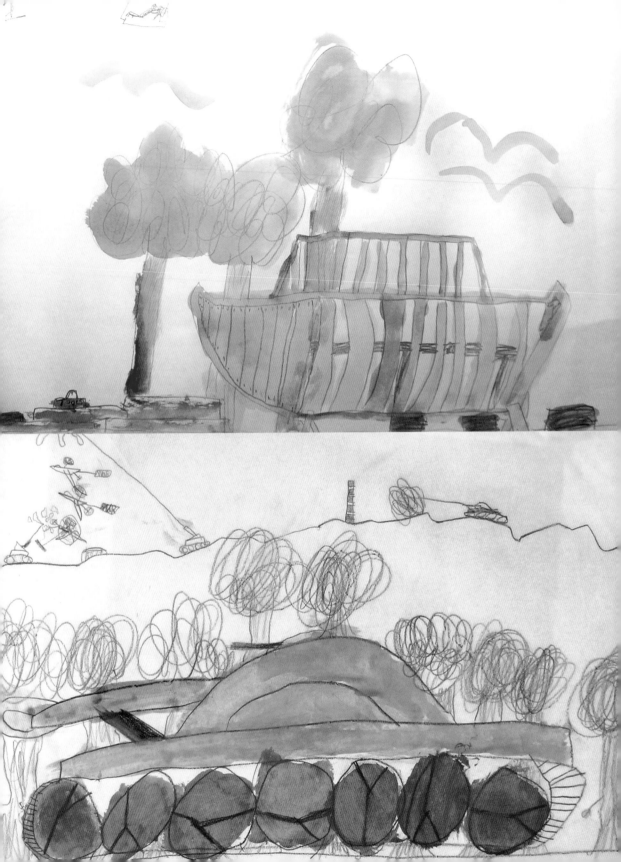

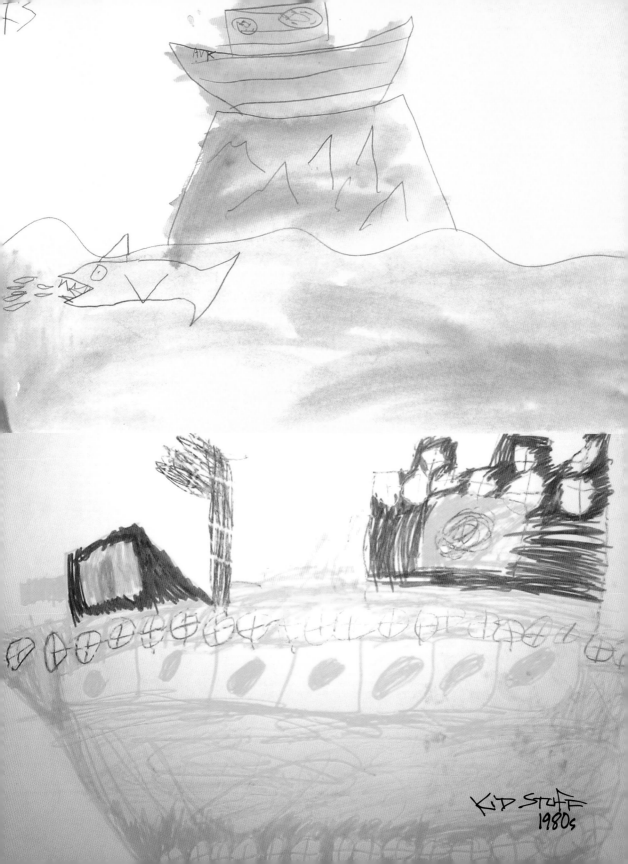

KiD STuFF
1980s

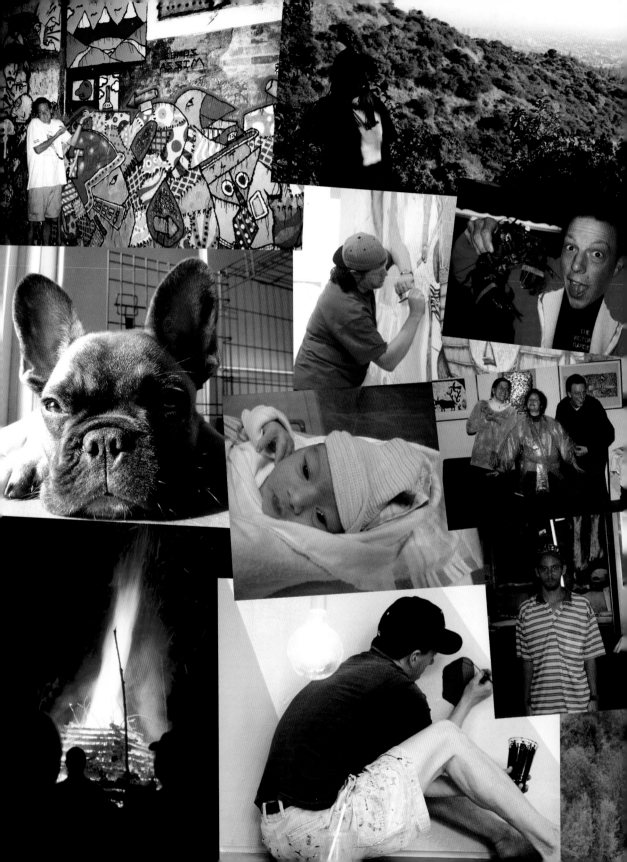

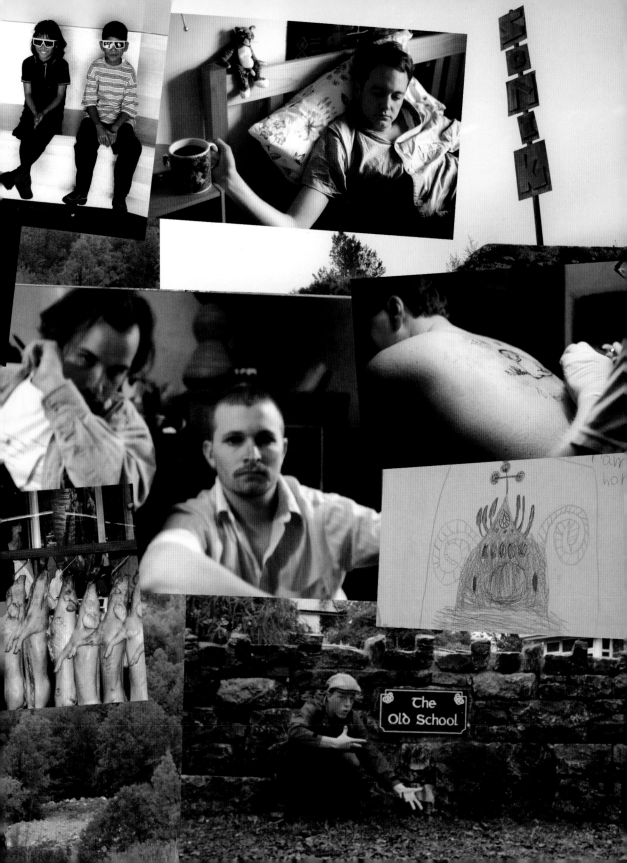

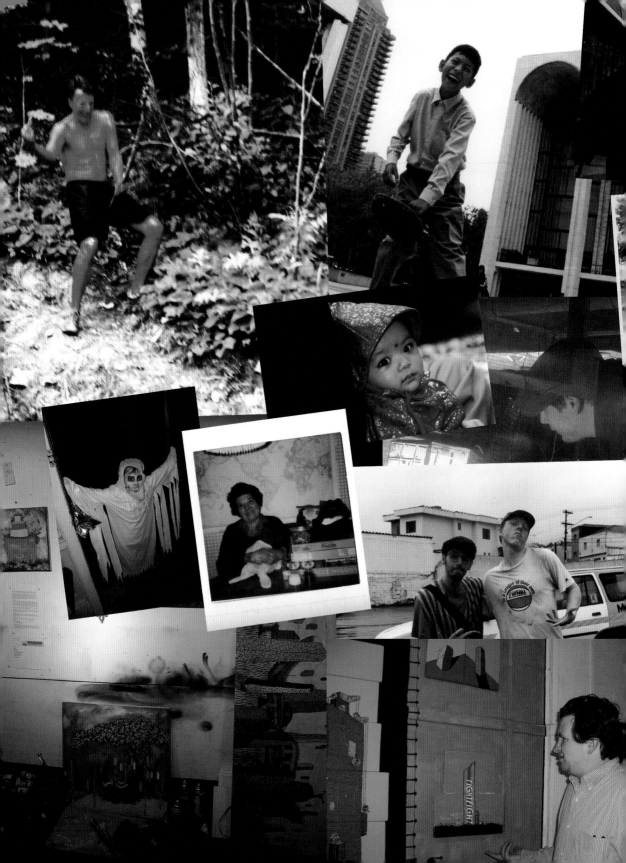

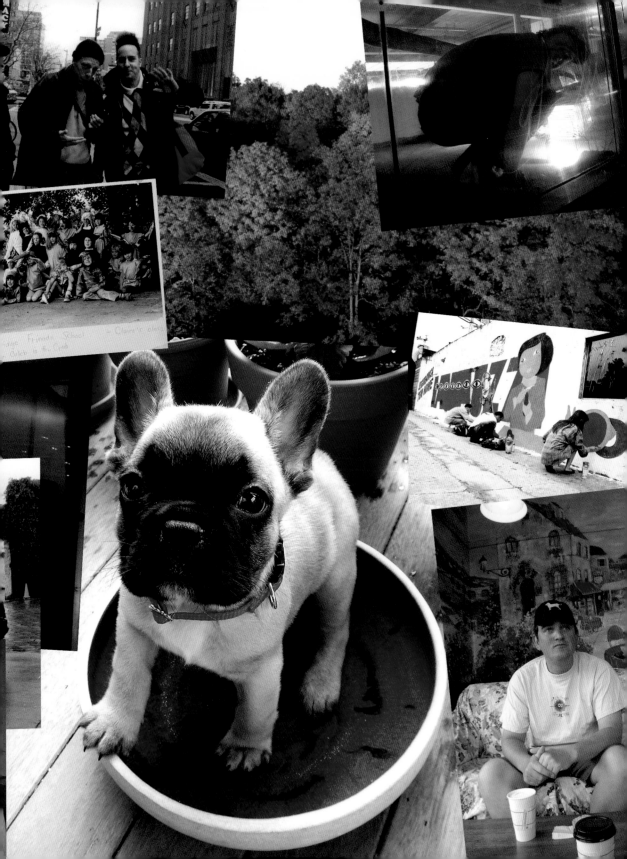

This book is dedicated to my family, and in gratitude to the memory of Tina Salipante & Roger Neelon.

Thank you:
Ellen, Sarah, Mom, Dad, Caroline, Rakesh, Monica, Prerna, Menu, Molly, Ashish, Suravi, Ma, Ba, Rabi, Prasoon, Shara, Evelyn, Annie, Ursie, Court, JD, Megan, Mike C, Mike R, Chris, Barbara, John, Rob, Jennifer, Kate B, Sam and Mara, Nadia, Jesse, Roger Gastman, Sonja Teri, Justin Van Hoy, Tony Smyrski, Ryan Shea-Paré, Alex Lukas, Andres Guerrero, Justin Giarla, Jeff Wardell, Adam Wallacavage, Peter Tannenbaum, Steve Powers, Judd Katz, Andy Schoultz, Dave Smith, Justin B. Williams, Brian Willmont, Becky Suss, Ben Woodward, Isaac Bell, Travis Roozée, Mike Alicea, Wendy Dembo, Joseph Pattisall, Aylin & Hakan, Tommi Laitio, Tristan Manco, Lost Art, Albano Mendes, Raven, Bare, Keramik, Os Gemeos, Ise, Koyo, Nunca, Nina, Vitche, Hence, SP, Aves, Mes, the Deez, Daze, Atome, Empo, Ichabod, Eratik, Monk, Cool Disco Dan, Giant, Tiws, Saber, Husk Mit Navn, Swindle, Print, Tokion, Alarm, Bant, WorldSign, Brain Damage, 12oz Prophet, Also Known As, Apenest, Underground Productions, Tony G, Cantab Publishing, Thames & Hudson, Abrams, Laura Donaldson, The Boston Center for the Arts, The Mass. Cultural Council, Ceci Mendez, The New Art Center, Shepard Fairey, Phil Frost, Adam Salacuse, Jane Feigenson, Jerry Beck, Lisa Giroday, Leon Catfish, Peter and Sharon Claesson, Fred Johnson, Charlie and Bibbi, Space 1026, Evos Arts, David and Dorothy Weidman, CFS, Farm and Wilderness, Patty, Parkman, Perdita, and Kendra at CA, Pat Hoy, Jessica Hoffmann Davis, Howard Gardner, Ed Emberley, David at Gingko, the people I forgot, and everyone who offers me an opportunity to do something fun, interesting, paying, or some combination of the three.

And Ferdinand.

Also by Caleb Neelon:

Lilman Makes a Name for Himself
Cantab Publishing, 2004. www.cantabpublishing.com

Graffiti Brasil (with Tristan Manco and Lost Art)
Thames and Hudson, 2005. www.graffitibrasil.com

Street World (with Roger Gastman and Anthony Smyrski)
Thames and Hudson / Abrams 2007. www.streetworldbook.com

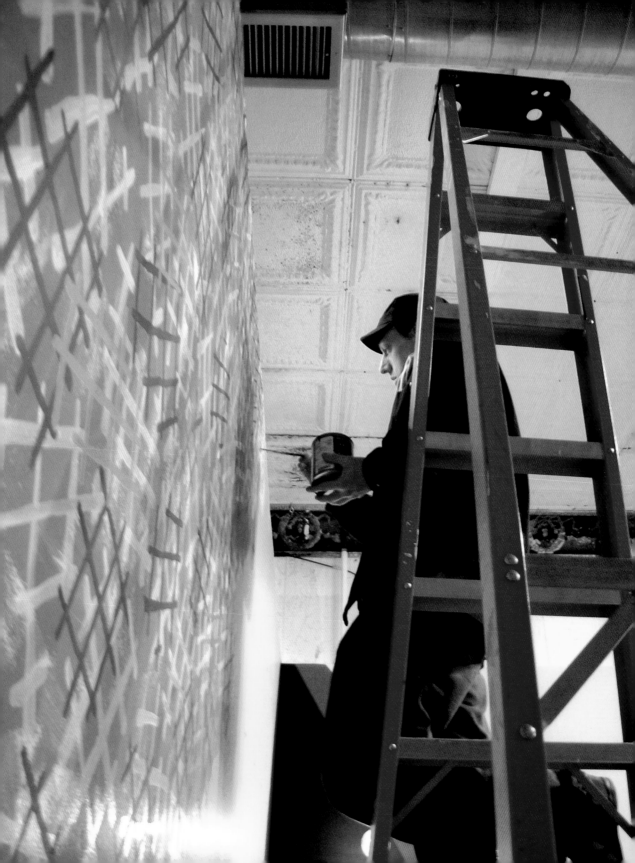